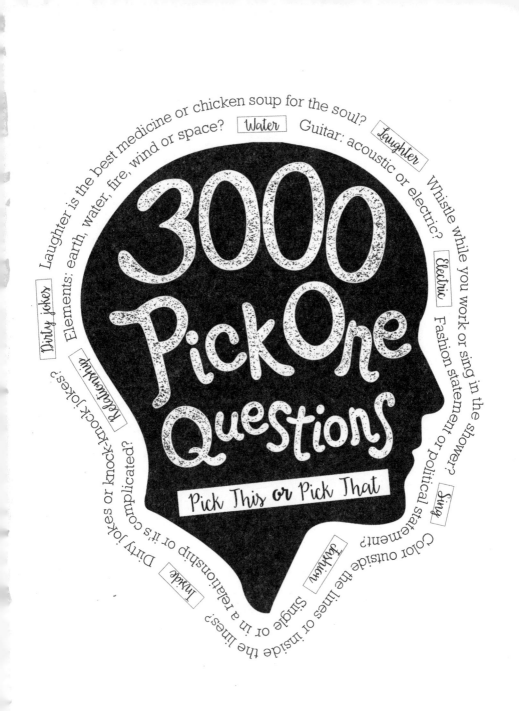

Follow us on social media!

Tag us and use #piccadillyinc in your posts
for a chance to win monthly prizes!

10 9 8 7 6 5 4 3 2 1

Printed in China

ISBN-13: 978-1-60863-449-1

1 Dancing or singing? (and why...)

2 Vintage or modern? (and why...)

3 Video games or board games? (and why...)

4 Dracula or Frankenstein? (and why...)

5 Candles or incense? (and why...)

6 5th Avenue or Rodeo Drive? (and why...)

7 Private jet or yacht? (and why...)

8 Chess or checkers? (and why...)

9 Snow cones or popsicles? (and why...)

10 M&M's or Skittles? (and why...)

11 Yogurt or cottage cheese? (and why...)

12 Netflix & chill or group date with friends? (and why...)

13 Lotus or orchid? (and why...)

14 Writing or painting? (and why...)

15 Scooby Doo or Snoopy? (and why...)

16 Plaid or paisley? (and why...)

17 Butterflies or dragon flies? (and why...)

18 Strawberries and cream or chocolate covered strawberries? (and why...)

19 Sorbet or gelato? (and why...)

20 Mix or match? (and why...)

21 Cappuccino or espresso? (and why...)

22 iSO or Android? (and why...)

23 Build a snowman or sandcastle? (and why...)

24 Doritos or Cheetos? (and why...)

25 Campfire or bonfire? (and why...)

26 Sunday fun day or lazy Sunday? (and why...)

27 Silver or gold? (and why...)

28 Sweet pickles or dill pickles? (and why...)

29 Dominos or mahjong? (and why...)

30 Twix or Kit Kat? (and why...)

31 Selfie: filter or no filter? (and why...)

32 Balloons or flowers? (and why...)

33 Salad or coleslaw? (and why...)

34 Cheerios or Rice Crispies? (and why...)

35 Cake or cookies? (and why...)

36 Pineapple or papaya? (and why...)

37 Spray tan or sun tan? (and why...)

38 Foot massage or back massage? (and why...)

39 Parrot or cockatoo? (and why...)

40 Church wedding or destination wedding? (and why...)

41 Start rumors or spread gossip? (and why...)

42 Soft tacos or crunchy tacos? (and why...)

43 Spicy or mild? (and why...)

44 Funnel cake or churros? (and why...)

45 Audi or Tesla? (and why...)

46 Croissant or scone? (and why...)

47 Amusement park or water park? (and why...)

48 Journaling or blogging? (and why...)

49 Spoon or fork? (and why...)

50 Pretzels or potato chips? (and why...)

51 Angry Birds or Candy Crush? (and why...)

52 Hot Pockets or Pizza Rolls? (and why...)

53 Lobster or shrimp? (and why...)

54 Lo Mein or fried rice? (and why...)

55 Chocolate covered cherries or chocolate covered raisins? (and why...)

56 Headphones or ear buds? (and why...)

57 Eggrolls or spring rolls? (and why...)

58 Puppies or kittens? (and why...)

59 Sunsets or sunrises? (and why...)

60 Fedora or baseball cap? (and why...)

61 Suede or leather? (and why...)

62 Blackjack or poker? (and why...)

63 Pancakes or waffles? (and why...)

64 Donuts or muffins? (and why...)

65 Summer or winter? (and why...)

66 French fries or onion rings? (and why...)

67 Sewing or crocheting? (and why...)

68 Pudding or Jell-O? (and why...)

69 S'mores or brownies? (and why...)

70 Flip flops or tennis shoes? (and why...)

71 Karaoke or charades? (and why...)

72 Hamster or chinchilla? (and why...)

73 White bread or wheat bread? (and why...)

74 Grape jelly or strawberry jelly? (and why...)

75 Mexican food or Italian food? (and why...)

76 Face your enemy or face your fear? (and why...)

77 Curly hair or straight hair? (and why...)

78 Whales or dolphins? (and why...)

79 Bagels or biscuits? (and why...)

80 Bowling or shooting pool? (and why...)

81 Drums or guitar? (and why...)

82 Donkey Kong or Pac-Man? (and why...)

83 Pug or Frenchie? (and why...)

84 Dim sum or sushi? (and why...)

85 Champagne or wine? (and why...)

86 Lake or beach? (and why...)

87 Unicorns or dragons? (and why...)

88 Leather jacket or hoodie? (and why...)

89 Chest bump or fist bump? (and why...)

90 Water ski or snow ski? (and why...)

91 Mohawk or man bun? (and why...)

92 Santorini or Ibiza? (and why...)

93 Green tea or herb tea? (and why...)

94 Shakes or malts? (and why...)

95 Hamburgers or hotdogs? (and why...)

96 Popcorn or cotton candy? (and why...)

97 Swiss or cheddar? (and why...)

98 Cream of Wheat or Malt O' Meal? (and why...)

99 Maple syrup or honey? (and why...)

100 Spaghetti or lasagna? (and why...)

101 Purple or green grapes? (and why...)

102 Jelly beans or gummy bears? (and why...)

103 Roller skate or ice skate? (and why...)

104 Fountain of youth or wishing well? (and why...)

105 Chameleon or iguana? (and why...)

106 Baseball or football? (and why...)

107 Ballet or opera? (and why...)

108 Mickey Mouse or Donald Duck? (and why...)

109 Jenga or Connect Four? (and why...)

110 Ranch or Thousand Island dressing? (and why...)

111 Mustard or Mayo? (and why...)

112 Rainy days or sunny days? (and why...)

113 Adventure seeker or couch potato? (and why...)

114 Bicycle or tricycle? (and why...)

115 Spontaneous or planner? (and why...)

116 Golf cart or four-wheeler? (and why...)

117 Chocolate or vanilla? (and why...)

118 Braids or ponytail? (and why...)

119 Yoga or Crossfit? (and why...)

120 Hammock or sofa? (and why...)

121 Grilled or fried? (and why...)

122 Picnic: park or beach? (and why...)

123 Romantic comedy or horror movie? (and why...)

124 Sailboat or speedboat? (and why...)

125 Seeded or unseeded bun? (and why...)

126 Goodie two-shoes or outlaw-ish? (and why...)

127 Brain surgeon or plastic surgeon? (and why...)

128 Turkey or ham? (and why...)

129 Forgive or hold a grudge? (and why...)

130 Peace maker or trouble maker? (and why...)

131 Baby goats or baby deer? (and why...)

132 Passive or aggressive? (and why...)

133 Humid or dry climate? (and why...)

134 Oreos or Chips Ahoy? (and why...)

135 Flannel pj bottoms or sweat pants? (and why...)

136 Popeye's or KFC? (and why...)

137 Mentos or Tic Tacs? (and why...)

138 Astronomy or archeology? (and why...)

139 Pen or pencil? (and why...)

140 Extra sleep or extra time? (and why...)

141 Saturday or Sunday? (and why...)

142 Marvel or DC? (and why...)

143 Flavored water or sparkling water? (and why...)

144 Dinosaurs or aliens? (and why...)

145 Cinnamon roll or French toast? (and why...)

146 Pumpkin spice: yes or no? (and why...)

147 Thin Mints or Caramel Delights? (and why...)

148 Scary or sexy costume? (and why...)

149 Gladiator or ninja? (and why...)

150 Running or swimming? (and why...)

151 Carnivore or vegetarian or vegan? (and why...)

152 Plants or flowers? (and why...)

153 Silly or serious? (and why...)

154 Employee or boss? (and why...)

155 Nerdy or weird? (and why...)

156 Really short or super tall? (and why...)

157 Celebrity: autograph or retweet your post? (and why...)

158 Cottage or cabin? (and why...)

159 *Ellen* or *Jimmy Fallon*? (and why...)

160 *The Academy Awards* or *The Grammys*? (and why...)

161 Condominium or townhouse? (and why...)

162 Mountains or desert? (and why...)

163 Retail therapy or therapy session? (and why...)

164 Long or short sleeve? (and why...)

165 College: yes or no? (and why...)

166 Vegetable or chicken noodle soup? (and why...)

167 Orange or apple juice? (and why...)

168 Play it safe or roll the dice? (and why...)

169 Mid-century Modern or Victorian? (and why...)

170 Sense of humor or sense of style? (and why...)

171 Palm or Magnolia tree? (and why...)

172 Frosted Flakes or Raisin Bran? (and why...)

173 Stripes or polka dots? (and why...)

174 Alaska or Hawaii? (and why...)

175 Engineer or architect? (and why...)

176 Shop: online or in store? (and why...)

177 Food: share or stingy? (and why...)

178 Banana nut or blueberry muffins? (and why...)

179 Peas or green beans? (and why...)

180 Cough syrup or cough drops? (and why...)

181 Solo artist or band? (and why...)

182 Symbols or cymbals? (and why...)

183 Spiders or snakes? (and why...)

184 Combat or cowboy boots? (and why...)

185 Ankle or crew socks? (and why...)

186 Own your truth or conformity? (and why...)

187 Angel or devil or a bit of both? (and why...)

188 Whisper or scream? (and why...)

189 Extroverted or introverted? (and why...)

190 Country music or rock and roll? (and why...)

191 Boisterous or humble? (and why...)

192 High five or handshake? (and why...)

193 Live long and prosper or hang loose? (and why...)

194 Burritos or enchiladas? (and why...)

195 Nursery rhymes or fairytales? (and why...)

196 *Jumanji* or *Jurassic Park*? (and why...)

197 Paris or Milan? (and why...)

198 Rattlesnake or Cobra? (and why...)

199 *Karate Kid* or *Back to the Future*? (and why...)

200 *Gone with the Wind* or *Casablanca*? (and why...)

201 Hippo or rhino? (and why...)

202 Chinese checkers or backgammon? (and why...)

203 Disney World or Six Flags? (and why...)

204 Buffalo or pizza? (and why...)

205 Apple or cherry pie? (and why...)

206 Vacation or staycation? (and why...)

207 Take a back road or familiar route? (and why...)

208 Pepper spray or taser? (and why...)

209 Grammar police or PC police? (and why...)

210 Pacific Coast Highway or Route 66? (and why...)

211 Roswell or Salem? (and why...)

212 Fluorescent colors or pastels? (and why...)

213 Kisses: forehead or cheek? (and why...)

214 Cuddle or snuggle? (and why...)

215 Chalk or marker? (and why...)

216 Toy Story or Shrek? (and why...)

217 Right brain or left brain? (and why...)

218 Fantasy sports leagues or online sports gaming? (and why...)

219 Mediate or negotiate? (and why...)

220 Hostile or accommodating? (and why...)

221 Somber or cheerful? (and why...)

222 Butterscotch or toffee? (and why...)

223 Minions or Oompa Loompas? (and why...)

224 Kiss on the first date or make them wait? (and why...)

225 He/she loves me, or he/she loves me not? (and why...)

226 Home cooked or dine out? (and why...)

227 Thrilling or boring? (and why...)

228 Pizza: round or square? (and why...)

229 Badminton or ping pong? (and why...)

230 Shooting star or rainbow? (and why...)

231 Purple or pink? (and why...)

232 Free-spirited or focused? (and why...)

233 Anger or compassion? (and why...)

234 Integrity or intensity? (and why...)

235 Deep dish or hand tossed or thin crust? (and why...)

236 Notes: write or record? (and why...)

237 Red velvet or black forest? (and why...)

238 Peek-a-boo or hide-and-seek? (and why...)

239 Reese's cups or Reese's pieces? (and why...)

240 Curly or crinkle cut fries? (and why...)

241 Red or green salsa? (and why...)

242 Niagara Falls or Victoria Falls? (and why...)

243 Macaroni and cheese or macaroni salad? (and why...)

244 Bacon or sausage? (and why...)

245 High road or low road? (and why...)

246 Blame or absolve? (and why...)

247 Fight or flee? (and why...)

248 Eye for an eye or turn the other cheek? (and why...)

249 Michelle Pfeiffer or Halle Berry? (and why...)

250 Fruit salad or garden salad? (and why...)

251 Adidas or Nike? (and why...)

252 Overbite or underbite? (and why...)

253 Gorgeous eyes or gorgeous smile? (and why...)

254 Tone or muscular? (and why...)

255 Coffin or cremation? (and why...)

256 Cherubs or leprechauns? (and why...)

257 Morning person or night owl? (and why...)

258 Breakfast or lunch or dinner? (and why...)

259 City or countryside? (and why...)

260 Stephen Hawking or Steve Jobs? (and why...)

261 Content or never satisfied? (and why...)

262 Marathon or triathlon? (and why...)

263 Soda or diet soda? (and why...)

264 Minimalist or lavish? (and why...)

265 Cookie dough or cake batter? (and why...)

266 Chicken nuggets or chicken fingers? (and why...)

267 Gatorade or Powerade? (and why...)

268 Dessert: first or last? (and why...)

269 Ice cream: waffle cone or regular cone? (and why...)

270 *Hawaii 5.0* or *Baywatch*? (and why...)

271 Surf or kayak? (and why...)

272 Bungee jump or skydive? (and why...)

273 Raffle ticket or lotto ticket? (and why...)

274 Blind date or online date? (and why...)

275 Chewbacca or R2D2? (and why...)

276 Juice cleanse or technology cleanse? (and why...)

277 Free climb or free fall? (and why...)

278 Cartier or Rolex? (and why...)

279 Army or Navy? (and why...)

280 Black and white or gray areas? (and why...)

281 Hopeless romantic or realistic? (and why...)

282 Books: digital or hardback or paperback? (and why...)

283 Black or red licorice? (and why...)

284 Salted caramel or salt water taffy? (and why...)

285 Mend fences or burn bridges? (and why...)

286 Trial: judge or jury? (and why...)

287 Drake or Jay-Z? (and why...)

288 Dark or milk chocolate? (and why...)

289 Swimsuit or skinny dip? (and why...)

290 Clean-shaven or rugged? (and why...)

291 Trusting or suspicious? (and why...)

292 Truth or dare? (and why...)

293 Phone call or text? (and why...)

294 Levi's or True Religion? (and why...)

295 Whistle while you work or sing in the shower? (and why...)

296 Facetime or Snapchat? (and why...)

297 Smile: teeth or no teeth? (and why...)

298 Breakfast for dinner or dinner for breakfast? (and why...)

299 Latte: hot or cold? (and why...)

300 Recycle: yes or no? (and why...)

301 Miracles or luck? (and why...)

302 Brunette or blonde? (and why...)

303 Flat tire or run out of gas? (and why...)

304 Veggie burger or turkey burger? (and why...)

305 Tornado or hurricane? (and why...)

306 Marinara or alfredo sauce? (and why...)

307 Gingerbread man or house? (and why...)

308 Garlic bread or cornbread? (and why...)

309 Rain coat or rain boots? (and why...)

310 Black beans or pinto beans? (and why...)

311 Stamp or coin collection? (and why...)

312 70s or 80s fashion? (and why...)

313 Life of the party or wallflower? (and why...)

314 Acupuncture or cupping? (and why...)

315 Skinny jeans or relaxed fit? (and why...)

316 V-neck or crew neck? (and why...)

317 Milk or soy milk or almond milk? (and why...)

318 Apple or pear? (and why...)

319 Algebra or geometry? (and why...)

320 Ruler or tape measure? (and why...)

321 Sincerely or Yours Truly? (and why...)

322 Corn: on the cob or off the cob? (and why...)

323 Target or Walmart? (and why...)

324 Sour cream or cream cheese? (and why...)

325 Ladybug or doodle bug? (and why...)

326 Nuts: dry roasted or honey roasted? (and why...)

327 Listerine or Scope? (and why...)

328 Visual or audible? (and why...)

329 Corvette or Camaro? (and why...)

330 Robot or drone? (and why...)

331 Fanta or Crush? (and why...)

332 Glass frames: round or traditional? (and why...)

333 Quarter Pounder or Big Mac? (and why...)

334 Cash or credit? (and why...)

335 Hot cocoa: whip cream or marshmallows or plain? (and why...)

336 Manicure or pedicure? (and why...)

337 Witty or charming? (and why...)

338 Butter or margarine? (and why...)

339 Trick or treat? (and why...)

340 Stand-up comedy or comedy sitcom? (and why...)

341 Soap: bar or liquid? (and why...)

342 Loofa or washcloth? (and why...)

343 Brush or comb? (and why...)

344 Spinach or kale? (and why...)

345 Cheese or animal crackers? (and why...)

346 Banana or plantain? (and why...)

347 *Harry Potter* or *Lord of the Rings?* (and why...)

348 Olives: black or green? (and why...)

349 7UP or Sprite? (and why...)

350 Oranges or tangerines? (and why...)

351 Solar power or battery power? (and why...)

352 Red wine or white wine? (and why...)

353 Chicken: dark or white meat? (and why...)

354 LG or Sony? (and why...)

355 Katy Perry or Taylor Swift? (and why...)

356 Little Debbie or Hostess? (and why...)

357 Optimistic or pessimistic? (and why...)

358 Broccoli or cauliflower? (and why...)

359 Bugs Bunny or Daffy Duck? (and why...)

360 Landscape or cityscape? (and why...)

361 Beauty or brains? (and why...)

362 Godzilla or King Kong? (and why...)

363 Dry cleaners or washing machine? (and why...)

364 Group date or one-on-one date? (and why...)

365 Parmesan or mozzarella? (and why...)

366 Prom or homecoming? (and why...)

367 Alfred Hitchcock or Stephen King? (and why...)

368 Michael Jackson or Prince? (and why...)

369 Adele or Pink? (and why...)

370 Pride or humility? (and why...)

371 Volunteer time or donate money? (and why...)

372 Safari or deep-sea expedition? (and why...)

373 Recliner or rocking chair? (and why...)

374 Sapphire or emerald? (and why...)

375 Home Depot or Lowe's? (and why...)

376 Amazon Echo or Google Home? (and why...)

377 *SNL* or *Good Morning America*? (and why...)

378 Parade or festival? (and why...)

379 *Wizard of Oz* or *Alice in Wonderland*? (and why...)

380 Gnome or Troll? (and why...)

381 *America's Got Talent* or *American Idol*? (and why...)

382 Blow bubbles or spray silly string? (and why...)

383 Wedding: throw rice or confetti? (and why...)

384 Carpet or tile or wooden flooring? (and why...)

385 Lemonade or limeade? (and why...)

386 Cherry or strawberry? (and why...)

387 Magic wand or magic carpet? (and why...)

388 *60 Minutes* or *Dateline*? (and why...)

389 Soy sauce or Sriracha? (and why...)

390 Lunch box or bento box? (and why...)

391 Knowledge or wisdom? (and why...)

392 Snowflake or icicle? (and why...)

393 Journey or wander? (and why...)

394 Luxury or efficiency? (and why...)

395 Creativity or ingenuity? (and why...)

396 War or peace? (and why...)

397 Reality TV or Soap Opera? (and why...)

398 Urban or rural? (and why...)

399 Guitar: acoustic or electric? (and why...)

400 Innovative or practical? (and why...)

401 Drive-thru or delivery? (and why...)

402 Hot sauce: yes or no? (and why...)

403 Canon or Nikon? (and why...)

404 Mercedes-Benz or BMW? (and why...)

405 Paddington or Winnie the Pooh? (and why...)

406 Ghost stories or urban legends? (and why...)

407 Cool Whip or Reddiwip? (and why...)

408 Charcoal or propane? (and why...)

409 Ray Ban or Oakley? (and why...)

410 Rare or medium or well done? (and why...)

411 Fruity Pebbles or Captain Crunch? (and why...)

412 Lays or Ruffles? (and why...)

413 Stick shift or automatic? (and why...)

414 Convertible top: yes or no? (and why...)

415 Family secrets or family traditions? (and why...)

416 Receive advice or give advice? (and why...)

417 Good listener or good conversation? (and why...)

418 Bean dip or cheese dip? (and why...)

419 Celery sticks or carrot sticks? (and why...)

420 Blue cheese or brie? (and why...)

421 Nose ring or belly ring? (and why...)

422 Cursive or print? (and why...)

423 Parsley or cilantro? (and why...)

424 Hummus or tzatziki? (and why...)

425 Octopus or squid? (and why...)

426 Caterpillar or earthworm? (and why...)

427 *Power Rangers* or *TMNT*? (and why...)

428 Ferret or guinea pig? (and why...)

429 Fortune teller or palm reader? (and why...)

430 Compass or canteen? (and why...)

431 Lust or love? (and why...)

432 Sudoku or crossword puzzle? (and why...)

433 Manhattan or Miami? (and why...)

434 Halloween or Christmas? (and why...)

435 Seashells or sea glass? (and why...)

436 Tambourine or harmonica? (and why...)

437 Air hockey or shuffleboard? (and why...)

438 Darts or archery? (and why...)

439 Ice cream sandwiches or Drumsticks? (and why...)

440 Spam or pigs' feet? (and why...)

441 Canned or frozen veggies? (and why...)

442 Chunky or creamy peanut butter? (and why...)

443 Pumpkin or sunflower seeds? (and why...)

444 High school or college? (and why...)

445 Hot air balloon or hang gliding? (and why...)

446 Keyboard or piano? (and why...)

447 Grilled cheese or BLT? (and why...)

448 Goldfish or Betta fish? (and why...)

449 Ivy or fern? (and why...)

450 Crown or tiara? (and why...)

451 Friendly or flirty? (and why...)

452 Robin or Blue Jay? (and why...)

453 Inner tube or raft? (and why...)

454 Panic room or hidden room? (and why...)

455 Cactus or succulent? (and why...)

456 Sign language or Morse code? (and why...)

457 Turtle or frog? (and why...)

458 Mediterranean or Caribbean cruise? (and why...)

459 Salmon or tuna? (and why...)

460 Ghost buster or ghost hunter? (and why...)

461 Pigeon or dove? (and why...)

462 Red or green tomato? (and why...)

463 Mashed potatoes: skins or no skins? (and why...)

464 Corn or flour tortillas? (and why...)

465 Soft or firm mattress? (and why...)

466 Electric or manual toothbrush? (and why...)

467 New car smell or money smell? (and why...)

468 Curtains or blinds? (and why...)

469 Screen calls or just answer? (and why...)

470 Kettle bells or free weights? (and why...)

471 Pray or meditate? (and why...)

472 Overachiever or slacker? (and why...)

473 Flood or fire? (and why...)

474 Belgian waffles or chocolate? (and why...)

475 Toilet paper roll: over or under? (and why...)

476 Zebra or giraffe? (and why...)

477 Scarf or tie? (and why...)

478 Fringe or feathers? (and why...)

479 PB&J or bologna sandwich? (and why...)

480 Flamingo or penguin? (and why...)

481 *God of War* or *Fortnite*? (and why...)

482 Clean car or clean bedroom? (and why...)

483 Splinter or hangnail? (and why...)

484 Horse or donkey? (and why...)

485 Futon or trundle bed? (and why...)

486 Lunar or solar eclipse? (and why...)

487 Bandana or headband? (and why...)

488 Wonder Woman or Superman? (and why...)

489 Diamonds or pearls? (and why...)

490 Comfort food or gourmet cuisine? (and why...)

491 Color outside the lines or inside the lines? (and why...)

492 Suede or velvet? (and why...)

493 Chutes and Ladders or Candy Land? (and why...)

494 North or South Pole? (and why...)

495 Roses or tulips? (and why...)

496 Etiquette: important or antiquated? (and why...)

497 Euro or Peso? (and why...)

498 Hula hoop or yoyo? (and why...)

499 Sketch pad or coloring book? (and why...)

500 Soccer or hockey? (and why...)

501 Midnight or noon? (and why...)

502 Chipmunk or chimpanzee? (and why...)

503 Dayglo or glitter? (and why...)

504 Tank top or t-shirt? (and why...)

505 Fitness goals or career goals? (and why...)

506 Sauce: BBQ or honey mustard? (and why...)

507 Sweet and sour or sweet and spicy? (and why...)

508 Green onion or purple onion or white onion? (and why...)

509 Stubborn or flexible? (and why...)

510 Compassionate or unsympathetic? (and why...)

511 Glass bottle or plastic bottle? (and why...)

512 Snorkel or scuba dive? (and why...)

513 Snobbish or sociable? (and why...)

514 Backpack or fanny pack? (and why...)

515 Necklace chain: herringbone or link? (and why...)

516 East coast or West coast? (and why...)

517 Tom Hanks or Tom Cruise? (and why...)

518 Dodgeball or volleyball? (and why...)

519 *A Christmas Story* or *National Lampoons Christmas Vacation*? (and why...)

520 *Bourne Identity* or *Mission Impossible*? (and why...)

521 Raisins or prunes? (and why...)

522 Piña colada or margarita? (and why...)

523 Cat nap or power nap? (and why...)

524 Quiche or pot pie? (and why...)

525 Slurp or smack? (and why...)

526 Ryan Reynolds or Ryan Gosling? (and why...)

527 Cotton or silk? (and why...)

528 Liberated or validated? (and why...)

529 Splenda or sugar? (and why...)

530 Onesie or thermal? (and why...)

531 Maya Angelou or Pablo Neruda? (and why...)

532 *Wheel of Fortune* or *Price is Right*? (and why...)

533 Freckles or dimples? (and why...)

534 Neutral or vibrant? (and why...)

535 Bathtub or shower? (and why...)

536 Organized or messy? (and why...)

537 *Grease* or *Hairspray*? (and why...)

538 Elderly or infants? (and why...)

539 Chopped or sliced? (and why...)

540 Bratwurst or Italian sausage? (and why...)

541 Hibiscus or gardenia? (and why...)

542 Idealistic or realistic? (and why...)

543 Sun or moon? (and why...)

544 Quirky or perky? (and why...)

545 Take control or go with the flow? (and why...)

546 Vans or Converse? (and why...)

547 Zipper or Velcro? (and why...)

548 Facebook or Instagram? (and why...)

549 Tweet or no tweet? (and why...)

550 Drive or fly? (and why...)

551 Total honesty or white lies? (and why...)

552 Bonsai tree or lucky bamboo plant? (and why...)

553 Zucchini or yellow squash? (and why...)

554 Fortune cookie or horoscope? (and why...)

555 Trail mix or granola? (and why...)

556 Club sandwich or sub sandwich? (and why...)

557 Classical or jazz? (and why...)

558 Vinyl or digital download (mp3)? (and why...)

559 Bob Marley or Jimi Hendrix? (and why...)

560 Disco or Indie? (and why...)

561 Porch swing or tire swing? (and why...)

562 *Daily Mail* or *Huffington Post*? (and why...)

563 School play or community theatre? (and why...)

564 Bingo or Solitaire? (and why...)

565 Origami or decoupage? (and why...)

566 Elevator or stairs? (and why...)

567 Principal or teacher? (and why...)

568 Sonic or Wendy's? (and why...)

569 Jiggle or wiggle? (and why...)

570 Front seat or back seat? (and why...)

571 Fashion show or car show? (and why...)

572 Sandwich: crusts on or crusts off? (and why...)

573 Trendy or hipster? (and why...)

574 *Dr. Oz* or *Dr. Phil?* (and why...)

575 *Friends* or *Seinfeld?* (and why...)

576 CBS or FOX? (and why...)

577 Adulthood or childhood? (and why...)

578 Coupons: yes or no? (and why...)

579 Samurai sword or machete? (and why...)

580 CNN or ESPN? (and why...)

581 Rollercoaster: front or back? (and why...)

582 College party or block party? (and why...)

583 Full or pouty lips? (and why...)

584 Nonchalant or inquisitive? (and why...)

585 PlayStation or Xbox? (and why...)

586 Déjà vu or déjà vécu? (and why...)

587 Superstitions or OCD? (and why...)

588 Angels or fairies? (and why...)

589 Cinderella or Snow White? (and why...)

590 Flavored coffee or creamer? (and why...)

591 Shake it off or shake it up? (and why...)

592 Snake charmer or lion tamer? (and why...)

593 Predictable or whimsical? (and why...)

594 Cats or dogs? (and why...)

595 Wedding photographer or wedding planner? (and why...)

596 Trip Advisor or Yelp? (and why...)

597 Spy or vigilante? (and why...)

598 Walk or jog? (and why...)

599 Maleficent or Ursula? (and why...)

600 Gym membership or home gym? (and why...)

601 Shredded or sliced cheese? (and why...)

602 Self-made or inherit money? (and why...)

603 Champion or challenger? (and why...)

604 Quest or mission? (and why...)

605 *Jetsons* or *Flintstones*? (and why...)

606 Jiu Jitsu or Karate? (and why...)

607 Poncho or sombrero? (and why...)

608 Funny bone or wishbone? (and why...)

609 Barbara Streisand or Dolly Parton? (and why...)

610 Xylophone or bongos? (and why...)

611 Volcano eruption or avalanche? (and why...)

612 One-story or two-story home? (and why...)

613 *E.T.* or *Gremlins*? (and why...)

614 Comedy: slapstick or satire? (and why...)

615 Pirate or captain? (and why...)

616 Gas or electric stove? (and why...)

617 Craft room or game room? (and why...)

618 Swimming pool or jacuzzi? (and why...)

619 *Indy 500* or *Kentucky Derby*? (and why...)

620 Defense or offense? (and why...)

621 *Tetris* or *Asteroids*? (and why...)

622 Merry-go-round or Ferris wheel? (and why...)

623 Jump rope or jumping jacks? (and why...)

624 Bowling or paint ball? (and why...)

625 Han Solo or Luke Skywalker? (and why...)

626 Play-Doh or silly putty? (and why...)

627 Treehouse or tiny house? (and why...)

628 Heavenly or hellish? (and why...)

629 Panda bear or koala bear? (and why...)

630 Tic-Tac-Toe or Hangman? (and why...)

631 Ring the bell or sound the alarm? (and why...)

632 Cubed or crushed ice? (and why...)

633 Elvis or The Beatles? (and why...)

634 *Vogue* or *Cosmopolitan*? (and why...)

635 Gift cards or actual gifts? (and why...)

636 *Time* or *People*? (and why...)

637 Gwen Stefani or Fergie? (and why...)

638 Arby's or Subway? (and why...)

639 Alarm clock: music or siren? (and why...)

640 Lacrosse or hockey? (and why...)

641 Cleopatra or Julius Caesar? (and why...)

642 Pelican or seagull? (and why...)

643 Hill or valley? (and why...)

644 Blow torch or tiki torch? (and why...)

645 Lavender or rosemary? (and why...)

646 Grass or sand? (and why...)

647 Energetic or electric? (and why...)

648 Wahlbergs or Wayans? (and why...)

649 Crème brûlée or bananas foster? (and why...)

650 Cookbook or scrapbook? (and why...)

651 Onyx or opal? (and why...)

652 Class ring or yearbook? (and why...)

653 Official or unofficial? (and why...)

654 Concert or festival? (and why...)

655 *Shawshank Redemption* or *The Green Mile*? (and why...)

656 Ernest Hemmingway or William Shakespeare? (and why...)

657 Lifeguard or paramedic? (and why...)

658 Rubik's Cube or Magic 8-Ball? (and why...)

659 Illuminati or Freemasons? (and why...)

660 Abs or biceps? (and why...)

661 Rooftop or underground? (and why...)

662 Dentist or podiatrist? (and why...)

663 Bigfoot or mermaid? (and why...)

664 Great white shark or killer whale? (and why...)

665 Seahorse or starfish? (and why...)

666 Black cat or broken mirror? (and why...)

667 Omelet or eggs Benedict? (and why...)

668 Telescope or microscope? (and why...)

669 Fire engine red or jet black? (and why...)

670 Protein shake or juice smoothie? (and why...)

671 Cyber bully or cyber stalk? (and why...)

672 Matchmaker or matchbreaker? (and why...)

673 Director or screenwriter? (and why...)

674 Independent thinker or peer pressure? (and why...)

675 Entourage or crew? (and why...)

676 Fickle or frugal? (and why...)

677 Modest or risqué? (and why...)

678 Hungry or hangry? (and why...)

679 Jaded or intense? (and why...)

680 Adam Sandler or Chris Rock? (and why...)

681 4-door or 2-door car? (and why...)

682 Sandstorm or blizzard? (and why...)

683 *Anchorman* or *Zoolander*? (and why...)

684 Handcrafted or mass produced? (and why...)

685 *Veronica Mars* or *Nancy Drew*? (and why...)

686 Spin the bottle or 7 minutes in heaven? (and why...)

687 *Paranormal Activity* or *Final Destination*? (and why...)

688 Lollipops or suckers? (and why...)

689 Litter or recycle? (and why...)

690 Polar bear or grizzly bear? (and why...)

691 Chug or gulp? (and why...)

692 Slimy or gooey? (and why...)

693 Alternative or mainstream? (and why...)

694 Las Vegas show or Broadway? (and why...)

695 Save or splurge? (and why...)

696 *Finding Dory* or *Finding Nemo*? (and why...)

697 Casual or formal? (and why...)

698 Biplane or helicopter? (and why...)

699 Toyota or Honda? (and why...)

700 Resort or bed and breakfast? (and why...)

701 Ride like the wind or need for speed? (and why...)

702 French dip or Reuben? (and why...)

703 Stallion or Clydesdale? (and why...)

704 Skechers or New Balance? (and why...)

705 Giggle or chuckle? (and why...)

706 *Miracle on 34th Street* or *It's a Wonderful Life?* (and why...)

707 Marilyn Monroe or Madonna? (and why...)

708 Fixer upper or turnkey? (and why...)

709 Waste time or waste money? (and why...)

710 *Beauty and the Beast* or *Little Mermaid?* (and why...)

711 Orchestra or symphony? (and why...)

712 Beast mode or savage? (and why...)

713 Pneumonia or flu? (and why...)

714 *Top Gun* or *Footloose?* (and why...)

715 Habit or ritual? (and why...)

716 Moth or fly? (and why...)

717 Tuba or saxophone? (and why...)

718 Gaze or daydream? (and why...)

719 Dirty laundry or dirty dishes? (and why...)

720 Willpower or mind over matter? (and why...)

721 Hello or hi? (and why...)

722 Barrier or obstacle? (and why...)

723 Tylenol or Advil? (and why...)

724 Chef or cook? (and why...)

725 Dabble or dawdle? (and why...)

726 Solitude or serenity? (and why...)

727 Pillow top or foam mattress? (and why...)

728 Couscous or quinoa? (and why...)

729 Limited edition or collector's edition? (and why...)

730 Chocolate bar or chocolate fountain? (and why...)

731 Pensive or persuasive? (and why...)

732 Sprinkler or Slip and Slide? (and why...)

733 Lentils or soybeans? (and why...)

734 Just Jared or TMZ? (and why...)

735 Brat Pack or Rat Pack? (and why...)

736 Candied bacon or candied apples? (and why...)

737 Sequins or gemstones? (and why...)

738 *Black Swan* or *Black Dahlia*? (and why...)

739 Guilty conscience or clear conscience? (and why...)

740 Mansion or castle? (and why...)

741 Burt's Bees or Chapstick? (and why...)

742 Philosophy or psychology? (and why...)

743 Past or present or future? (and why...)

744 Hand sanitizer or moist towelettes? (and why...)

745 American Express or Visa? (and why...)

746 Cotton swabs or cotton balls? (and why...)

747 Science experiment or social experiment? (and why...)

748 Starbucks or Dunkin' Donuts? (and why...)

749 One Direction or One Republic? (and why...)

750 *Hamilton* or *Wicked*? (and why...)

751 Step show or talent show? (and why...)

752 Sorority/fraternity: good or bad? (and why...)

753 Tinted windows: yes or no? (and why...)

754 Times Square or Tiananmen Square? (and why...)

755 Fabric or leather car seats? (and why...)

756 *Dancing with the Stars* or *So You Think You Can Dance?* (and why...)

757 Olivia Benson or Dana Scully? (and why...)

758 *X-Files* or *Twilight Zone?* (and why...)

759 Clover or patchouli? (and why...)

760 Lighthouses or landmarks? (and why...)

761 Electric eel or stingray? (and why...)

762 Etiquette or courtesy? (and why...)

763 Shallow or hollow? (and why...)

764 Chicken pox or measles? (and why...)

765 Thin or thick? (and why...)

766 Pinky promise or swear? (and why...)

767 *Tom & Jerry* or *Ren & Stimpy?* (and why...)

768 Trampoline or bouncy house? (and why...)

769 Dog walking or babysitting? (and why...)

770 Vlog or podcast? (and why...)

771 TV reboots: *Roseanne* or *Will & Grace?* (and why...)

772 Junk food or clean eating? (and why...)

773 Watermelon or cantaloupe? (and why...)

774 Jigsaw puzzle or word search puzzles? (and why...)

775 *Sponge Bob* or *Pokémon?* (and why...)

776 Wilderness or wonderland? (and why...)

777 Parafoil or kite? (and why...)

778 Personal trainer or train yourself? (and why...)

779 Motivate or inspire? (and why...)

780 Bumble bee or honey bee? (and why...)

781 History or science? (and why...)

782 Plead or beg? (and why...)

783 Fab Fit Fun box or Birchbox? (and why...)

784 Bubble bath or mud bath? (and why...)

785 Menu or buffet? (and why...)

786 Fiction or non-fiction? (and why...)

787 Earrings: hoops or studs? (and why...)

788 Dinner party or brunch party? (and why...)

789 Pilates or aerobics? (and why...)

790 Comic book or comic strip? (and why...)

791 Horticulture or anthropology? (and why...)

792 Farmer or beekeeper? (and why...)

793 Zone or mojo? (and why...)

794 Glossy or flossy? (and why...)

795 Nimble or clumsy? (and why...)

796 Anime or classic cartoony? (and why...)

797 Visionary or innovative? (and why...)

798 Masquerade ball or toga party? (and why...)

799 Pogo stick or stilts? (and why...)

800 Firecrackers or skyrockets? (and why...)

801 Costa Rica or Cancun? (and why...)

802 Avalon or Atlantis? (and why...)

803 Flea market or antique shop? (and why...)

804 Mind reader or psychic? (and why...)

805 Airplane: carry on or baggage check? (and why...)

806 Ghost or demon? (and why...)

807 Frumpy or statuesque? (and why...)

808 First class or coach? (and why...)

809 Single or in a relationship or it's complicated? (and why...)

810 High jump or long jump? (and why...)

811 Free throw or three-point shot? (and why...)

812 Summer or Winter Olympics? (and why...)

813 Written or video diary? (and why...)

814 Brown or white gravy? (and why...)

815 Grace or mercy? (and why...)

816 Salisbury steak or meatloaf? (and why...)

817 Sautéed mushrooms or onions or both? (and why...)

818 Candy corn or candy cane? (and why...)

819 High top or low top sneakers? (and why...)

820 Graphic designer or production designer? (and why...)

821 Bold or italic? (and why...)

822 Piranha or barracuda? (and why...)

823 Peter Pan or Pinocchio? (and why...)

824 Satchel or messenger bag? (and why...)

825 Backstroke or butterfly stroke? (and why...)

826 Casino or lottery? (and why...)

827 *Moby Dick* or *Wuthering Heights*? (and why...)

828 Potato chips: plain or sour cream & onion or BBQ? (and why...)

829 Gumball or gumdrop? (and why...)

830 Austin City Limits or Coachella? (and why...)

831 Clingy or dingy? (and why...)

832 Farmville or Words with Friends? (and why...)

833 Bison or venison? (and why...)

834 Sublet or lease? (and why...)

835 Moocher or squatter? (and why...)

836 Think tank or dream team? (and why...)

837 Calm or crunk? (and why...)

838 News anchor or weather anchor? (and why...)

839 Skip or hop? (and why...)

840 Treble or bass? (and why...)

841 Mushy or fluffy? (and why...)

842 Gazebo or sun porch? (and why...)

843 People person or animal lover? (and why...)

844 Subtle or candid? (and why...)

845 Cargo or capri? (and why...)

846 Curious or indifferent? (and why...)

847 Pond or bayou? (and why...)

848 Frolic or jubilation? (and why...)

849 Treasure or time capsule? (and why...)

850 Galapagos or Virgin Islands? (and why...)

851 Seal or walrus? (and why...)

852 Mechanical or technical? (and why...)

853 Sketchy or shady? (and why...)

854 Eminem or Lil Dicky? (and why...)

855 Spring fling or summer romance? (and why...)

856 *Diary of Anne Frank* or *Diary of a Wimpy Kid*? (and why...)

857 Memoir or biography? (and why...)

858 Rave or riot? (and why...)

859 Flat iron or curling iron? (and why...)

860 Genie in a bottle or mirror, mirror on the wall? (and why...)

861 Marc Jacobs or Tory Burch? (and why...)

862 Mules or clogs? (and why...)

863 Pinwheels or kaleidoscopes? (and why...)

864 Walkie talkie or megaphone? (and why...)

865 Bounce or pounce? (and why...)

866 Fundraiser or raffle? (and why...)

867 Collage or single picture frame? (and why...)

868 Prada or Coach? (and why...)

869 Dandelions or wildflowers? (and why...)

870 Poinsettia or mistletoe? (and why...)

871 Central Park or Balboa Park? (and why...)

872 Tour guide or mascot? (and why...)

873 Scrumptious or delicious? (and why...)

874 Zoo or aquarium? (and why...)

875 Nibble or grub? (and why...)

876 Outdoors or indoors? (and why...)

877 Clap back or applause? (and why...)

878 Taxi or Uber? (and why...)

879 Empire or estate? (and why...)

880 Small business or corporation? (and why...)

881 Fashion or furniture designer? (and why...)

882 Square or round dining table? (and why...)

883 Old Navy or H&M? (and why...)

884 Fish tank or herb garden? (and why...)

885 Overrated or underestimated? (and why...)

886 Queen or King? (and why...)

887 Right handed or left handed? (and why...)

888 Lone wolf or wolf pack? (and why...)

889 Tasteful or tacky? (and why...)

890 Handwritten or typed? (and why...)

891 Exfoliate or rejuvenate? (and why...)

892 Special K or Shredded Wheat? (and why...)

893 Peaches or plums? (and why...)

894 Crab cakes or hush puppies? (and why...)

895 Consumer or connoisseur? (and why...)

896 Trader Joe's or Whole Foods? (and why...)

897 Cross or locket? (and why...)

898 Ascot or handkerchief? (and why...)

899 *Point Break* or *Matrix*? (and why...)

900 Loyalty or honesty? (and why...)

901 Spice Girls or Pussycat Dolls? (and why...)

902 Yeti or Igloo? (and why...)

903 Fingers or toes? (and why...)

904 Supportive or critical? (and why...)

905 Vincent Van Gogh or Pablo Picasso? (and why...)

906 Black and white or subtitled movies? (and why...)

907 Scented or unscented? (and why...)

908 Frothy or foamy? (and why...)

909 Pita or naan bread? (and why...)

910 Meatballs or falafel? (and why...)

911 Cafeteria or diner? (and why...)

912 *Pretty in Pink* or *Pretty Woman*? (and why...)

913 *The Starry Night* or *Mona Lisa*? (and why...)

914 Verb or noun? (and why...)

915 Runaway or daydreamer? (and why...)

916 Hair: ombré or highlights? (and why...)

917 Gorilla glue or Super Glue? (and why...)

918 Slide or monkey bars? (and why...)

919 Planetarium or observatory? (and why...)

920 Denim or bomber jacket? (and why...)

921 Button down or pullover? (and why...)

922 Cain or Abel? (and why...)

923 Racquetball or handball? (and why...)

924 HBO or Showtime? (and why...)

925 Steampunk or Rockabilly? (and why...)

926 Sofa cushions or under car seats? (and why...)

927 Drinking straw or no straw? (and why...)

928 Hay or straw? (and why...)

929 Day planner or digital calendar? (and why...)

930 USA or Cartoon Network? (and why...)

931 Boxers or briefs? (and why...)

932 High tide or low tide? (and why...)

933 Ice or slushy? (and why...)

934 Mango or papaya? (and why...)

935 Marmalade or fig preserves? (and why...)

936 Harvest moon or blue moon? (and why...)

937 Maroon 5 or Kings of Leon? (and why...)

938 Literal or figurative? (and why...)

939 Australian or French accent? (and why...)

940 Mockingbird or raven? (and why...)

941 Industrial or Bohemian? (and why...)

942 Sauna or steam room? (and why...)

943 Soft baked or crispy pretzel? (and why...)

944 Perks or bonuses? (and why...)

945 Shield or armor? (and why...)

946 Sword or spear? (and why...)

947 Brothers Grimm or Grim Reaper? (and why...)

948 Pixar or DreamWorks? (and why...)

949 Morph or transformation? (and why...)

950 Full moon or crescent moon? (and why...)

951 Medusa or Godiva? (and why...)

952 Muhammed Ali or Floyd Mayweather? (and why...)

953 Emilia Earhart or Joan of Arc? (and why...)

954 Fiesta or siesta? (and why...)

955 Obi Wan Kenobi or Yoda? (and why...)

956 Investor or financier? (and why...)

957 Chili: beans or no beans? (and why...)

958 Yield or caution? (and why...)

959 Calypso or reggae? (and why...)

960 Mardi Gras or Oktoberfest? (and why...)

961 T-Rex or Brontosaurus? (and why...)

962 Root beer or ginger ale? (and why...)

963 Activist or philanthropist? (and why...)

964 Paradise or heaven? (and why...)

965 Early or on time or late? (and why...)

966 Twilight or dawn? (and why...)

967 Sugar cookies or Snickerdoodles? (and why...)

968 RV or Airstream trailer? (and why...)

969 Pop Tart or Toaster Strudel? (and why...)

970 Taco Cabana or Taco Bell? (and why...)

971 Hilton or Holiday Inn? (and why...)

972 Wrestling or boxing? (and why...)

973 Michael Jordan or Kobe Bryant? (and why...)

974 Purpose or passion? (and why...)

975 Rental car or ride share? (and why...)

976 Famous or infamous? (and why...)

977 Bold or brave? (and why...)

978 Warrior or vigilante? (and why...)

979 Cemetery or corn fields? (and why...)

980 Spiritual or spirited? (and why...)

981 Venus Fly Trap or Praying Mantis? (and why...)

982 Tarantula or Black Widow? (and why...)

983 Strobe light or disco ball? (and why...)

984 Organic or gluten free? (and why...)

985 Argue or agree? (and why...)

986 Jackie Chan or Bruce Lee? (and why...)

987 Dominos or Pizza Hut? (and why...)

988 Cheesecake or key lime pie? (and why...)

989 Trophy or medal? (and why...)

990 Treadmill or stair climber? (and why...)

991 Pressure cooker or crockpot? (and why...)

992 Conservative or liberal? (and why...)

993 Bengal or Siberian tiger? (and why...)

994 Owl or woodpecker? (and why...)

995 Frappuccino or iced coffee? (and why...)

996 Dougie or NaeNae? (and why...)

997 People or bird watching? (and why...)

998 *Noah's Ark* or *Titanic*? (and why...)

999 Sourdough or pumpernickel? (and why...)

1000 Zombies: walkers or crawlers? (and why...)

1001 Tuna or egg salad? (and why...)

1002 Written or video diary? (and why...)

1003 Miniature or tea cup dog? (and why...)

1004 Empowering or uplifting? (and why...)

1005 Shadow or silhouette? (and why...)

1006 Doctor's office or emergency room? (and why...)

1007 Jokes or one liners? (and why...)

1008 Sugar coated or harsh? (and why...)

1009 Plaza or mall? (and why...)

1010 Trouble or double trouble? (and why...)

1011 Resume or recommendation? (and why...)

1012 LinkedIn or Indeed? (and why...)

1013 Memorial or tombstone? (and why...)

1014 Rain or handheld showerhead? (and why...)

1015 White collar or blue collar? (and why...)

1016 Down in flames or blaze of glory? (and why...)

1017 Keep or break promises? (and why...)

1018 Debate or debunk? (and why...)

1019 Epitaph or epithet? (and why...)

1020 Trailblazer or trendsetter? (and why...)

1021 Torque or horsepower? (and why...)

1022 Coke or Pepsi? (and why...)

1023 Dentist or orthodontist? (and why...)

1024 Acapella or accompanied? (and why...)

1025 Red Cross or UNICEF? (and why...)

1026 Luggage: wheels or no wheels? (and why...)

1027 *Pitch Black* or *Men in Black*? (and why...)

1028 Sponsor or donate? (and why...)

1029 Teacakes or tea sandwiches? (and why...)

1030 Tap or bottled water? (and why...)

1031 *Little Shop of Horrors* or *Rocky Horror Picture Show*? (and why...)

1032 Corgi butts or rabbit noses? (and why...)

1033 Mummification or cryogenics? (and why...)

1034 Genealogy or archeology? (and why...)

1035 Burberry or Louis Vuitton? (and why...)

1036 Turquoise or teal? (and why...)

1037 Slow dancing or line dancing? (and why...)

1038 Deli or bakery? (and why...)

1039 Yin or Yang? (and why...)

1040 Lagoon or river? (and why...)

1041 Around the world or cross country? (and why...)

1042 Spiderweb or ant mound? (and why...)

1043 Jeep or Range Rover? (and why...)

1044 Chanel or Tom Ford? (and why...)

1045 Hallmark or Lifetime movies? (and why...)

1046 Bidet: yes or no? (and why...)

1047 Daddy's girl or momma's boy? (and why...)

1048 Swedish or stone massage? (and why...)

1049 Cuttlefish or pufferfish? (and why...)

1050 Seasoned or curly fries? (and why...)

1051 Bubble or Matcha tea? (and why...)

1052 Grateful or appreciative? (and why...)

1053 Lend or borrow? (and why...)

1054 Baseball or basketball jersey? (and why...)

1055 Atlantic or Pacific Ocean? (and why...)

1056 Amazon or Nile River? (and why...)

1057 Bear Grylls or Les Stroud? (and why...)

1058 Salvation Army or Goodwill? (and why...)

1059 Royal wedding or celebrity wedding? (and why...)

1060 Tina Turner or Whitney Houston? (and why...)

1061 Visual album or music video? (and why...)

1062 Bartender or barista? (and why...)

1063 Radio City Music Hall or Grand Old Opry? (and why...)

1064 *Saved by the Bell* or *All That*? (and why...)

1065 DJ Khaled or David Guetta? (and why...)

1066 March or rally? (and why...)

1067 ACLU or PETA? (and why...)

1068 *Glee* or *Scream Queens*? (and why...)

1069 Race car driver or horse jockey? (and why...)

1070 Meghan Markle or Kate Middleton? (and why...)

1071 Nut butter or cookie butter? (and why...)

1072 Rockette or Showgirl? (and why...)

1073 French press or automatic drip coffee makers? (and why...)

1074 SPCA or Humane Society? (and why...)

1075 *The Sound of Music* or *Mary Poppins*? (and why...)

1076 Horizontal or vertical or diagonal? (and why...)

1077 Bachelor party or bridal shower? (and why...)

1078 Motion sickness or vertigo? (and why...)

1079 Hershey or Cadbury? (and why...)

1080 Folklore or folktale? (and why...)

1081 Get mad or get even? (and why...)

1082 Windmills or waterfalls? (and why...)

1083 Canasta or pinochle? (and why...)

1084 Hologram or virtual reality? (and why...)

1085 Sizzle or sear? (and why...)

1086 GIFs or memes? (and why...)

1087 Concierge or valet? (and why...)

1088 Board game: CLUE or Monopoly? (and why...)

1089 Newspaper or magazine? (and why...)

1090 Fajitas or kebabs? (and why...)

1091 Reindeer or antelope? (and why...)

1092 Footprints or fingerprints? (and why...)

1093 Detective or P.I.? (and why...)

1094 Even or odd? (and why...)

1095 Overachiever or slacker? (and why...)

1096 Contacts or glasses? (and why...)

1097 Fantasy or sci-fi? (and why...)

1098 Pine Sol or Mr. Clean? (and why...)

1099 Dominant or submissive? (and why...)

1100 Vampires or werewolves? (and why...)

1101 Perfume or body spray? (and why...)

1102 Cologne or musk? (and why...)

1103 Nordstrom or Macy's? (and why...)

1104 Crazy or sane? (and why...)

1105 Evolve or adapt? (and why...)

1106 Butterfly effect or halo effect? (and why...)

1107 Library or bookstore? (and why...)

1108 Foolish or gullible? (and why...)

1109 Food or movie critic? (and why...)

1110 T-Mobile or Verizon? (and why...)

1111 Hibiscus or honeysuckle? (and why...)

1112 Chips: corn or potato? (and why...)

1113 *Jingle Bells* or *Silent Night?* (and why...)

1114 *Jack and the Beanstalk* or *Goldilocks and the Three Bears?* (and why...)

1115 Braces or retainer? (and why...)

1116 Bad breath or body odor? (and why...)

1117 Frank Sinatra or Michael Bublé? (and why...)

1118 Black Jack or Spades? (and why...)

1119 Social media or social event? (and why...)

1120 Dog park or cat café? (and why...)

1121 Miso or wonton soup? (and why...)

1122 Alligator tail or frog legs? (and why...)

1123 Snails or oysters? (and why...)

1124 Minivan or station wagon? (and why...)

1125 *Game of Thrones* or *True Blood?* (and why...)

1126 Escape room or haunted house? (and why...)

1127 Snow mobile or jet ski? (and why...)

1128 Yoo-hoo or Nesquik? (and why...)

1129 Bugs Bunny or Peter Rabbit? (and why...)

1130 Sloppy Joes or Philly cheesesteak? (and why...)

1131 Maraschino or Bing cherries? (and why...)

1132 Barbershop or salon? (and why...)

1133 Venus or Serena Williams? (and why...)

1134 Billboard or iTunes music chart? (and why...)

1135 *Rolling Stone* or *GQ*? (and why...)

1136 Farmers Market or marketplace? (and why...)

1137 Sun roof or moon roof? (and why...)

1138 Polarized or gradient tint for sunglasses? (and why...)

1139 Fried pickles or fried zucchini? (and why...)

1140 Grocery list or to do list? (and why...)

1141 Frankly or bluntly? (and why...)

1142 Bumper stickers: yes or no? (and why...)

1143 Hors d'oeuvres or appetizers? (and why...)

1144 Omen or sign? (and why...)

1145 Love at first sight: yes or no? (and why...)

1146 Primitive or futuristic? (and why...)

1147 Movie score or movie cinematography? (and why...)

1148 Cell phone: screen protector or case? (and why...)

1149 Diligent or demanding? (and why...)

1150 Splish or splash? (and why...)

1151 Poppies or sunflowers? (and why...)

1152 Aerial or ground level? (and why...)

1153 Camel or llama? (and why...)

1154 Local radio station or playlists? (and why...)

1155 Hand puppet or marionette? (and why...)

1156 Cocoa butter or shea butter? (and why...)

1157 Lemon Drops or Red Hots? (and why...)

1158 Lips: pucker or pout? (and why...)

1159 Snack size or full size? (and why...)

1160 Cayenne or chili flakes? (and why...)

1161 Pottery or carpentry? (and why...)

1162 PayPal or Venmo? (and why...)

1163 Quilt or afghan? (and why...)

1164 Short films or short stories? (and why...)

1165 *A Walk to Remember* or *The Fault in Our Stars*? (and why...)

1166 Principles or ethics? (and why...)

1167 Oil or vinegar? (and why...)

1168 Sled or wagon? (and why...)

1169 Brooklyn or Bronx? (and why...)

1170 Russet potatoes or red potatoes? (and why...)

1171 Chicken and dumplings or matzo ball soup? (and why...)

1172 Camouflage or tribal print? (and why...)

1173 Samoan or Sumo wrestlers? (and why...)

1174 Rachel or Monica? (and why...)

1175 Bright white or off white? (and why...)

1176 Piggy back or shoulder ride? (and why...)

1177 Vibes or energy? (and why...)

1178 Soba or ramen noodles? (and why...)

1179 Bear or crab crawl? (and why...)

1180 Protest or boycott? (and why...)

1181 Fish sticks or corn dogs? (and why...)

1182 Karma or fate? (and why...)

1183 Laptop or desktop? (and why...)

1184 Procrastinate or persist? (and why...)

1185 Mattel or Hasbro? (and why...)

1186 Ceiling or oscillating fan? (and why...)

1187 Creature or critter? (and why...)

1188 Wayfair or Overstock? (and why...)

1189 Pier 1 or Pottery Barn? (and why...)

1190 Art supplies or craft supplies? (and why...)

1191 Hollywood or Beverly Hills? (and why...)

1192 Chance or gamble? (and why...)

1193 Beers or cocktails? (and why...)

1194 Thrive or survive? (and why...)

1195 Dubai or Abu Dhabi? (and why...)

1196 Reflexology or aromatherapy? (and why...)

1197 Granny or Fuji apple? (and why...)

1198 Risotto or gnocchi? (and why...)

1199 Waxing or threading? (and why...)

1200 Sauerkraut or kimchi? (and why...)

1201 Ketchup: squeeze or glass bottle? (and why...)

1202 Tarter or cocktail sauce? (and why...)

1203 Menace or nuisance? (and why...)

1204 Speed of light or speed of sound? (and why...)

1205 Spaceship or rocket ship? (and why...)

1206 Barter or negotiate? (and why...)

1207 Tortellini or ravioli? (and why...)

1208 Learn or teach? (and why...)

1209 Milky Way or 3 Musketeers? (and why...)

1210 Beets or pomegranate? (and why...)

1211 Ring doorbell or knock? (and why...)

1212 Blue, green or hazel eyes? (and why...)

1213 Asparagus or brussels sprouts? (and why...)

1214 Fascinate or mesmerize? (and why...)

1215 Venice or Amsterdam? (and why...)

1216 Pepitas or flax seeds? (and why...)

1217 Fred Astaire or Derek Hough? (and why...)

1218 Frizzy or tangled hair? (and why...)

1219 Prescription or holistic? (and why...)

1220 Brittany Spears or Christina Aguilera? (and why...)

1221 Carry a torch or eternal flame? (and why...)

1222 R&B or Hip Hop? (and why...)

1223 Innocent or guilty? (and why...)

1224 Ginger Rogers or Jennifer Lopez? (and why...)

1225 Soda: bottle or can? (and why...)

1226 Purgatory or underworld? (and why...)

1227 Life of the party or wallflower? (and why...)

1228 Out of control or out on a limb? (and why...)

1229 Porsche or Ferrari? (and why...)

1230 Remodel or renovate? (and why...)

1231 Stiff or flexible? (and why...)

1232 Donut or croissant? (and why...)

1233 Heavy bag or uppercut bag? (and why...)

1234 Graffiti or murals? (and why...)

1235 Ball point or felt-tip pen? (and why...)

1236 Assume or ask? (and why...)

1237 Shampoo or conditioner? (and why...)

1238 Hairspray or hair gel? (and why...)

1239 Piggy bank or coin bank? (and why...)

1240 Blackheads or zits? (and why...)

1241 Air freshener or potpourri? (and why...)

1242 Handlebar or Chevron mustache? (and why...)

1243 Handsfree or hands on? (and why...)

1244 Charlie Brown or Linus? (and why...)

1245 Pewter or bronze? (and why...)

1246 Vase or basket? (and why...)

1247 Iron your clothes or leave wrinkled? (and why...)

1248 Centipede or beetle? (and why...)

1249 Moonlight or night light? (and why...)

1250 Live stream or viral? (and why...)

1251 Victorious or prosperous? (and why...)

1252 Bruno Mars or The Weekend? (and why...)

1253 Stuffed mushrooms or stuffed jalapenos? (and why...)

1254 Subtle or obvious? (and why...)

1255 Breakup: text or in person? (and why...)

1256 Royalty or diplomat? (and why...)

1257 John Cabot or Christopher Columbus? (and why...)

1258 Violin or harp? (and why...)

1259 Imagine Dragons or Cage the Elephant? (and why...)

1260 Sand tarts or Madeleines? (and why...)

1261 Yale or Harvard? (and why...)

1262 Piñata or bob for apples? (and why...)

1263 Macaroon or macaron? (and why...)

1264 Bingo or Keno? (and why...)

1265 Mad scientist or nutty professor? (and why...)

1266 Jackie O or Grace Kelly? (and why...)

1267 Meat: marinate or tenderize? (and why...)

1268 Hermit crab or gecko? (and why...)

1269 Woven or leather belt? (and why...)

1270 Tooth fairy or boogie man? (and why...)

1271 Macramé or dreamcatcher? (and why...)

1272 Charts or graphs? (and why...)

1273 Aloe Vera or Echinacea? (and why...)

1274 Cindy Crawford or Sophia Vergara? (and why...)

1275 Legacy or heritage? (and why...)

1276 Cheer or rant? (and why...)

1277 Thumb ring or pinky ring? (and why...)

1278 Windy or breezy? (and why...)

1279 John Carpenter or Mary Shelley? (and why...)

1280 Somersault or back flip? (and why...)

1281 Best friend or best buddy? (and why...)

1282 Times New Roman or Arial? (and why...)

1283 Sardines or anchovies? (and why...)

1284 Dodge: Charger or Challenger? (and why...)

1285 Caesar or cobb salad? (and why...)

1286 Spoof or mock? (and why...)

1287 Circle of life or dog eat dog? (and why...)

1288 Emblem or logo? (and why...)

1289 Drama or mystery? (and why...)

1290 Andy Warhol or Roy Lichtenstein? (and why...)

1291 Single or double burger? (and why...)

1292 Dance or cooking lessons? (and why...)

1293 Albert Einstein or Isaac Newton? (and why...)

1294 Motion sickness or vertigo? (and why...)

1295 Highway or toll road? (and why...)

1296 Side by side or top and bottom refrigerator? (and why...)

1297 Pantene or L'Oréal? (and why...)

1298 Dishwasher or handwash? (and why...)

1299 Caress or Dove body soap? (and why...)

1300 Treehouse or jungle gym? (and why...)

1301 Slogan or jingle? (and why...)

1302 Pope or Dalai Lama? (and why...)

1303 Pigs in a blanket or kolache? (and why...)

1304 MLK or Malcom X? (and why...)

1305 Gentrification: yes or no? (and why...)

1306 Gumbo or bisque? (and why...)

1307 Hallmark or American Greetings? (and why...)

1308 Photoshop: yes or no? (and why...)

1309 Boutique or resale shops? (and why...)

1310 Infinity or Olympic swimming pool? (and why...)

1311 Polish or Italian sausage? (and why...)

1312 Nectar or juice? (and why...)

1313 Look your age or act your age? (and why...)

1314 Melancholy or brooding? (and why...)

1315 9 to 5 or graveyard shift? (and why...)

1316 Topo Chico or Jarritos? (and why...)

1317 Sleep: on your side, on your stomach or on your back? (and why...)

1318 Early bird gets the worm or hit the snooze button? (and why...)

1319 Midnight snack: always or never? (and why...)

1320 Dr. Pepper or Mr. Pibb? (and why...)

1321 Painted or chrome car rims? (and why...)

1322 Live band or DJ? (and why...)

1323 Romper or overalls? (and why...)

1324 Morgan Freeman or Samuel L. Jackson? (and why...)

1325 Security guard or security cameras? (and why...)

1326 Midas Touch or Achilles heel? (and why...)

1327 Sickle or trident? (and why...)

1328 Curry or jerk spices? (and why...)

1329 Intern or assistant? (and why...)

1330 Family reunions or flash mob? (and why...)

1331 Polished or professional resume? (and why...)

1332 Honk or beep? (and why...)

1333 Splenda or Stevia? (and why...)

1334 Avocado or coconut oil? (and why...)

1335 Heartbreak or heartbeat? (and why...)

1336 Thai or Vietnamese food? (and why...)

1337 Guacamole or sour cream? (and why...)

1338 Gaming chair or bean bag? (and why...)

1339 Cosmetic dentistry or plastic surgery? (and why...)

1340 Wassail or fruit punch? (and why...)

1341 Belt or suspenders? (and why...)

1342 Donate blood or clothing? (and why...)

1343 Kool-Aid or Country Time? (and why...)

1344 Refried or charro beans? (and why...)

1345 Family or tribe? (and why...)

1346 Teamwork or partnership? (and why...)

1347 Imprint or engrave? (and why...)

1348 Inner strength or determination? (and why...)

1349 Eddie Murphy or Jim Carrey? (and why...)

1350 *Hangover* or *Bridesmaids*? (and why...)

1351 Swimsuit: one piece or bikini? (and why...)

1352 Moccasins or slippers? (and why...)

1353 Chill or decompress? (and why...)

1354 Store bought or homemade pasta? (and why...)

1355 Panettone or fruit cake? (and why...)

1356 Protein or energy bars? (and why...)

1357 *Star Wars* or *Star Trek*? (and why...)

1358 Trench coat or parka? (and why...)

1359 Sponge or pound cake? (and why...)

1360 Network or socialize? (and why...)

1361 Steve Carell or Tina Fey? (and why...)

1362 Petition or picketing? (and why...)

1363 Rice or sticky pudding? (and why...)

1364 Triscuit or Wheat Thins? (and why...)

1365 Sour or tart? (and why...)

1366 Red Bull or Monster? (and why...)

1367 Crispy or crunchy? (and why...)

1368 Ponzi or pyramid scheme? (and why...)

1369 FBI or CIA? (and why...)

1370 Sugar free or low calorie? (and why...)

1371 Well-rounded or well adjusted? (and why...)

1372 Power walk or sprint? (and why...)

1373 Choir or marching band? (and why...)

1374 Steamed or pan-fried pot stickers? (and why...)

1375 Pork rinds or corn nuts? (and why...)

1376 Tennis bracelet or bangle? (and why...)

1377 Spunky or lethargic? (and why...)

1378 Devil's food or angel food cake? (and why...)

1379 Soulmates or kindred spirits? (and why...)

1380 Carriage ride or trail ride? (and why...)

1381 Neck or body pillow? (and why...)

1382 Deviled eggs or pickled eggs? (and why...)

1383 Jekyll and Hyde or alter ego? (and why...)

1384 Motorcycle with sidecar or extra seating? (and why...)

1385 YMCA or LA Fitness? (and why...)

1386 Artichoke hearts or hearts of palm? (and why...)

1387 Independent or codependent? (and why...)

1388 Lantern or oil lamp? (and why...)

1389 Breadsticks or cheese sticks? (and why...)

1390 St. Jude's or Make-A-Wish? (and why...)

1391 Prince Harry or Prince William? (and why...)

1392 Eiffel Tower or Taj Mahal? (and why...)

1393 *Big Brother* or *Real World*? (and why...)

1394 Capers or sun-dried tomatoes? (and why...)

1395 Mother Goose or Mother Teresa? (and why...)

1396 Feather or down pillow? (and why...)

1397 Wrought iron fence or white picket fence? (and why...)

1398 Motive or intention? (and why...)

1399 Physical or mental attraction? (and why...)

1400 April showers or May flowers? (and why...)

1401 Tropicana or Minute Maid? (and why...)

1402 Controversy or scandal? (and why...)

1403 Sparkle or shine? (and why...)

1404 Jam or preserves? (and why...)

1405 Skyscraper or tower? (and why...)

1406 Clam or pickle juice? (and why...)

1407 Hanes or Fruit of the Loom? (and why...)

1408 English muffin or crumpet? (and why...)

1409 Firefighter or search and rescue? (and why...)

1410 Memories or moments? (and why...)

1411 Rage or fury? (and why...)

1412 Twins or triplets? (and why...)

1413 Habitat for Humanity or Ronald McDonald House? (and why...)

1414 Clambake or crab boil? (and why...)

1415 Chrysler or Empire State Building? (and why...)

1416 Rock, paper or scissors? (and why...)

1417 Psychological warfare or mind games? (and why...)

1418 Dell or HP computer? (and why...)

1419 Jeff Bezos or Bill Gates? (and why...)

1420 Puppet master or puppet on a string? (and why...)

1421 Out of sight, out of mind or absence makes the heart grow fonder? (and why...)

1422 Draw straws or flip a coin? (and why...)

1423 Brain power or brute strength? (and why...)

1424 Metallica or Megadeth? (and why...)

1425 Ultimate or deluxe? (and why...)

1426 Hustle or overtime? (and why...)

1427 Vineyard or brewery? (and why...)

1428 Pastry chef or Sous chef? (and why...)

1429 White Castle or In-N-Out? (and why...)

1430 Rice crispy treats or popcorn balls? (and why...)

1431 Cliff jump or base jump? (and why...)

1432 Splinter or papercut? (and why...)

1433 Credit union or bank? (and why...)

1434 Favored or underdog? (and why...)

1435 *Sherlock Holmes* or *Hercule Poirot*? (and why...)

1436 Actions speak louder than words or the pen is mightier than the sword? (and why...)

1437 Pinball machine or arcade machine? (and why...)

1438 *NCIS* or *Law & Order: Special Victims Unit*? (and why...)

1439 Shark Week or *Sharknado*? (and why...)

1440 Rewards: cash back or flyer miles? (and why...)

1441 *Home Alone* or *Home Alone 2: Lost in New York?* (and why...)

1442 Cumulus or cirrus clouds? (and why...)

1443 Renaissance or street fair? (and why...)

1444 Big Dipper or Orion? (and why...)

1445 Blue or black ink? (and why...)

1446 Jumper cables or spare tire? (and why...)

1447 Spa day or shopping spree? (and why...)

1448 Fuzzy or toe socks? (and why...)

1449 Solstice: summer or winter? (and why...)

1450 Colonel Mustard or Mrs. Peacock? (and why...)

1451 Drive-in or dive? (and why...)

1452 Clocktower or bell tower? (and why...)

1453 *Gray's Anatomy* or *ER?* (and why...)

1454 Eternal life or reincarnation? (and why...)

1455 CPR or Heimlich maneuver? (and why...)

1456 Pepperoni or salami? (and why...)

1457 Spray or roll-on deodorant? (and why...)

1458 Finders keepers or lost and found? (and why...)

1459 Basil or oregano? (and why...)

1460 Church or cathedral? (and why...)

1461 Light or deep sleeper? (and why...)

1462 Dry or fresh herbs? (and why...)

1463 Mr. Potato Head or Buzz Lightyear? (and why...)

1464 Logical or obscure? (and why...)

1465 Explore or analyze? (and why...)

1466 Hawaiian shirt or ugly sweater? (and why...)

1467 Horseshoes or cornhole? (and why...)

1468 Fake or real flowers? (and why...)

1469 Marzipan or meringue cookies? (and why...)

1470 Welder or plumber? (and why...)

1471 Sweater or denim vest? (and why...)

1472 Juggle or balance? (and why...)

1473 High dive platform or diving board? (and why...)

1474 Debt or indebted? (and why...)

1475 Feedback or constructive criticism? (and why...)

1476 Gush or blush? (and why...)

1477 Bounty hunter or prison guard? (and why...)

1478 Paved or dirt road? (and why...)

1479 Mobster or gangster? (and why...)

1480 Leverage or extortion? (and why...)

1481 University or junior college? (and why...)

1482 Online or correspondence course? (and why...)

1483 Seizure or stroke? (and why...)

1484 Subaru or Kia? (and why...)

1485 Workshop or conference? (and why...)

1486 Infant or toddler? (and why...)

1487 Sleep with TV off or on? (and why...)

1488 Name brand or generic? (and why...)

1489 Hot or cold shower? (and why...)

1490 Cotton or silk sheets? (and why...)

1491 Savings or retirement account? (and why...)

1492 Dental floss or toothpicks? (and why...)

1493 Wireless or hardwired? (and why...)

1494 Paper or cloth napkins? (and why...)

1495 Unusual or unique? (and why...)

1496 Riding lawn mower or push mower? (and why...)

1497 GoPro or Garmin VIRB? (and why...)

1498 Fitness tracker or smartwatch? (and why...)

1499 Soup or chowder? (and why...)

1500 Sandwiches or wraps? (and why...)

1501 Vitamins: chewable or capsule? (and why...)

1502 Los Angeles or Manhattan? (and why...)

1503 Cellphone holder: belt clip or arm strap? (and why...)

1504 Buttercream or whipped cream frosting? (and why...)

1505 Fly or gnat? (and why...)

1506 Sightseeing or historic tour? (and why...)

1507 Valuable lessons or learn from your mistakes? (and why...)

1508 Stitches or broken bone? (and why...)

1509 Type A or B personality? (and why...)

1510 Ask permission or ask for forgiveness? (and why...)

1511 Early bird gets the worm or the second mouse gets the cheese? (and why...)

1512 Censorship: yes or no? (and why...)

1513 Talk show or gossip column? (and why...)

1514 Doctor or lawyer? (and why...)

1515 Elements: earth, water, fire, wind or space? (and why...)

1516 Organic chemistry or physical chemistry? (and why...)

1517 Lust or love? (and why...)

1518 Punch or kick? (and why...)

1519 Mature or immature? (and why...)

1520 Growth or stagnant? (and why...)

1521 Retribution or pardon? (and why...)

1522 Animated or apathetic? (and why...)

1523 Teriyaki or tempura? (and why...)

1524 Traditional or button-down collar? (and why...)

1525 French or Milanese shirt cuffs? (and why...)

1526 Stud button or toggle cufflink? (and why...)

1527 T-Bone or filet mignon steak? (and why...)

1528 Cinnamon or nutmeg? (and why...)

1529 *Lost Boys* or *Interview with the Vampire*? (and why...)

1530 Low carb or low-calorie diet? (and why...)

1531 Keto or paleo? (and why...)

1532 Beats or Bose headphones? (and why...)

1533 Small town or big city? (and why...)

1534 Watch or play sports? (and why...)

1535 Game face or poker face? (and why...)

1536 Count Chocula or Boo Berry or Franken Berry cereal? (and why...)

1537 Personal assistant or personal chef? (and why...)

1538 Vacuum or sweep? (and why...)

1539 Suit or tuxedo? (and why...)

1540 Nachos or Frito pie? (and why...)

1541 Stir fry or deep fry? (and why...)

1542 Fishing: boat or pier? (and why...)

1543 TV dinner or Chef Boyardee? (and why...)

1544 Apple juice or cider? (and why...)

1545 Mouse or rat? (and why...)

1546 Chauffeur or butler? (and why...)

1547 Limo or party bus? (and why...)

1548 Breakfast in bed or skip breakfast? (and why...)

1549 TGI Friday's or Chili's? (and why...)

1550 Princess or pear cut diamond? (and why...)

1551 Poison ivy or heat rash? (and why...)

1552 Turban or slouchy hat? (and why...)

1553 Culinary tour or pub crawl? (and why...)

1554 *Zombie Apocalypse* or *Armageddon*? (and why...)

1555 Prayer or candlelight vigil? (and why...)

1556 Lilies or daisies? (and why...)

1557 Weight Watchers or Jenny Craig? (and why...)

1558 Herbal or seaweed body wrap? (and why...)

1559 *Emmy* or *Tony Award*? (and why...)

1560 5-Star or casual dining? (and why...)

1561 Bamboo or wicker? (and why...)

1562 Pralines or Moon Pies? (and why...)

1563 Go-karts or bumper cars? (and why...)

1564 Snakeskin or alligator boots? (and why...)

1565 Soufflé or mousse? (and why...)

1566 Chocolate or canary diamond? (and why...)

1567 By the slice or whole pie? (and why...)

1568 Yard or estate sale? (and why...)

1569 Blow dry or dry hair naturally? (and why...)

1570 Tumble dry clothes or hang outside on line? (and why...)

1571 Mindful or thoughtful? (and why...)

1572 Laid back or uptight? (and why...)

1573 Bird bath or bird feeder? (and why...)

1574 Coloring book or paint by numbers? (and why...)

1575 Alfalfa sprouts or bean sprouts? (and why...)

1576 Python or anaconda? (and why...)

1577 Railroad or subway? (and why...)

1578 Fax or scan? (and why...)

1579 Birthday or anniversary? (and why...)

1580 Shock or startle? (and why...)

1581 Drive alone or carpool? (and why...)

1582 Shenanigans or debauchery? (and why...)

1583 Sob or cry? (and why...)

1584 Bliss or benevolence? (and why...)

1585 Husky or German Shepherd? (and why...)

1586 Hand wash or machine wash your car? (and why...)

1587 Baby powder or baby lotion? (and why...)

1588 Doormat or stepping stone? (and why...)

1589 Sinister or bewitched? (and why...)

1590 Welcoming or hospitable? (and why...)

1591 Laser tag or flag football? (and why...)

1592 Ziplining or hang gliding? (and why...)

1593 Swirl or scoop of ice cream? (and why...)

1594 Sound mind or level head? (and why...)

1595 Authentic or fusion cooking? (and why...)

1596 Lip gloss or lipstick? (and why...)

1597 Sheer or tinted? (and why...)

1598 Short or long fingernails? (and why...)

1599 Burrito or empanada? (and why...)

1600 Guy Fieri or Bobby Flay? (and why...)

1601 Retinal or thumbprint scan access? (and why...)

1602 Cauldron or kettle? (and why...)

1603 Magic spell or magic potion? (and why...)

1604 *Dallas* or *Dynasty* reboot? (and why...)

1605 Suspended or grounded? (and why...)

1606 Cellulite or stretch marks? (and why...)

1607 Espadrilles or loafers? (and why...)

1608 Crocs or Dr. Scholl's? (and why...)

1609 Broke or paid? (and why...)

1610 Thumper or Bambi? (and why...)

1611 Sticky or itchy? (and why...)

1612 Calligraphy or stencil? (and why...)

1613 WWE or MMA? (and why...)

1614 Unstoppable or invincible? (and why...)

1615 *The Muppets* or *Sesame Street?* (and why...)

1616 Swim: ocean or pool? (and why...)

1617 Keep a secret or keep a promise? (and why...)

1618 Blind or deaf? (and why...)

1619 Salary or hourly rate? (and why...)

1620 Work hard or play hard? (and why...)

1621 Fondue or chili con queso? (and why...)

1622 Cheerleader or drill team? (and why...)

1623 Brown or white rice? (and why...)

1624 Beeswax or soy candle? (and why...)

1625 Mancave or she shed? (and why...)

1626 Thermos or tumbler? (and why...)

1627 Entomology or taxonomy? (and why...)

1628 Tax or gratuity? (and why...)

1629 Insource or outsource? (and why...)

1630 Stargazing or geocaching? (and why...)

1631 Scotland or Ireland? (and why...)

1632 Statue of Liberty or Mount Rushmore? (and why...)

1633 Golden Gate Bridge or Brooklyn Bridge? (and why...)

1634 Fashion or Runway model? (and why...)

1635 Keep pennies: yes or no? (and why...)

1636 Stand up paddle boarding or white-water rafting? (and why...)

1637 Economic or extravagant? (and why...)

1638 Grand Canyon or Yosemite? (and why...)

1639 *Madame Butterfly* or *Phantom of the Opera?* (and why...)

1640 Peanut butter or salted caramel? (and why...)

1641 Chunky Monkey or Chubby Hubby? (and why...)

1642 Beastie Boys or Run DMC? (and why...)

1643 Mechanical or regular pencil? (and why...)

1644 Paella or jambalaya? (and why...)

1645 Tomato or carrot juice? (and why...)

1646 Balsamic or red wine vinegar? (and why...)

1647 Fruit Roll-Ups or Air Heads? (and why...)

1648 Crepes or knish? (and why...)

1649 Lightsaber or magic staff? (and why...)

1650 United or Delta Airlines? (and why...)

1651 Reliable or unpredictable? (and why...)

1652 Ube or taro? (and why...)

1653 Dandruff or hair loss? (and why...)

1654 Applause or cheer? (and why...)

1655 Sahara or Gobi Desert? (and why...)

1656 Pork chops or lamb chops? (and why...)

1657 Urban Outfitters or Forever 21? (and why...)

1658 Asthma or acid reflux? (and why...)

1659 Truffles or caviar? (and why...)

1660 Chex Mix or Bugles? (and why...)

1661 Monkey bread or garlic knots? (and why...)

1662 Horseradish or aioli? (and why...)

1663 Polaroid or Kodak? (and why...)

1664 Pop culture or nostalgic? (and why...)

1665 Egg whites or whole egg? (and why...)

1666 Double chin or saggy skin? (and why...)

1667 Roller derby or rugby? (and why...)

1668 Pushups or sit ups? (and why...)

1669 Bill Nye the Science Guy or Jack Hanna? (and why...)

1670 Barley or lentils? (and why...)

1671 Saint or sinner? (and why...)

1672 Control or let go? (and why...)

1673 *Ice Age* or *Frozen*? (and why...)

1674 Dr. Seuss or R.L. Stein? (and why...)

1675 Fidget spinner or stress ball? (and why...)

1676 Howl or bark? (and why...)

1677 Diarrhea or vomit? (and why...)

1678 Design or layout? (and why...)

1679 Flight or x-ray vision? (and why...)

1680 Mayhem or disaster? (and why...)

1681 Adopt a baby or pet? (and why...)

1682 Bistro or pâtisserie? (and why...)

1683 Sea salt or kosher salt? (and why...)

1684 Troop leader or Little League coach? (and why...)

1685 Pep talk or confidence boost? (and why...)

1686 Angles or curves? (and why...)

1687 Mesquite or hickory? (and why...)

1688 Jogging or yoga pants? (and why...)

1689 Armadillo or opossum? (and why...)

1690 Cold nose or cold toes? (and why...)

1691 Breyers or Blue Bunny Ice Cream? (and why...)

1692 Touchscreen: yes or no? (and why...)

1693 Protagonist or antagonist? (and why...)

1694 Fireplace or fire pit? (and why...)

1695 Leg warmers or knee high socks? (and why...)

1696 Rocky road or cookies and cream? (and why...)

1697 Wishbone or funny bone? (and why...)

1698 Cranberry or orange juice? (and why...)

1699 Chubby or skinny? (and why...)

1700 Crest or Colgate? (and why...)

1701 Insecure or secure? (and why...)

1702 Bad habits or one vice? (and why...)

1703 School uniforms: good or bad? (and why...)

1704 Teddy bear or security blanket? (and why...)

1705 First aid kit or roadside assistance kit? (and why...)

1706 Pick a side or stay neutral? (and why...)

1707 Fine Art Museum or Science Museum? (and why...)

1708 Oval or round face? (and why...)

1709 Static electricity or white noise? (and why...)

1710 Bad hair day or bad mood? (and why...)

1711 Addiction or connection? (and why...)

1712 NASA or Kennedy Space Center? (and why...)

1713 Blackmail or extortion? (and why...)

1714 Riot or brawl? (and why...)

1715 Twizzlers or Swedish Fish? (and why...)

1716 Distortion or clarity? (and why...)

1717 Kiwi or dragon fruit? (and why...)

1718 Chopsticks or fingers? (and why...)

1719 Nickel or brass finish? (and why...)

1720 Pendant light or chandelier? (and why...)

1721 Stonehenge or Easter Island? (and why...)

1722 Fabric softener or dryer sheets? (and why...)

1723 Lifesavers or Altoids? (and why...)

1724 Ambrosia salad or divinity fluff? (and why...)

1725 Al dente or mushy? (and why...)

1726 Existential crisis or crisis of faith? (and why...)

1727 Orbitz or Expedia? (and why...)

1728 Aurora Borealis or Sea of Stars? (and why...)

1729 Twinkies or Ding Dongs? (and why...)

1730 Goblet or fluted glass? (and why...)

1731 Medallion or locket? (and why...)

1732 Falkor or Pegasus? (and why...)

1733 Charm or I.D. bracelet? (and why...)

1734 Skeleton key or lock picks? (and why...)

1735 Single or second helping? (and why...)

1736 *The Nutcracker* or *Swan Lake*? (and why...)

1737 Forward progress or roadblock? (and why...)

1738 NERDS or Pop Rocks? (and why...)

1739 Real or fake fur? (and why...)

1740 Elderberry or gooseberry? (and why...)

1741 Rubber tree or banana plant? (and why...)

1742 Animal Planet or Discovery Channel? (and why...)

1743 Wind chimes or wind spinner? (and why...)

1744 Scare Tactics or Fear Factor? (and why...)

1745 Voodoo priest or witch doctor? (and why...)

1746 Considerate or inconsiderate? (and why...)

1747 Waterfront or hillside? (and why...)

1748 Chalet or cabin? (and why...)

1749 Purebred or mix breed? (and why...)

1750 Cartoon Network or TV Land? (and why...)

1751 Criss Angel or David Blaine? (and why...)

1752 Pig tails or pony tail? (and why...)

1753 Nude beach or pose nude? (and why...)

1754 *Jungle Book* or *Tarzan*? (and why...)

1755 Basement or attic? (and why...)

1756 Monster Mash or Thriller? (and why...)

1757 Frugal or lavish? (and why...)

1758 Acorn or hazelnut? (and why...)

1759 Beignets or sopaipilla? (and why...)

1760 Northern or Southern hemisphere? (and why...)

1761 Scribble or doodle? (and why...)

1762 Salt lamp or lava lamp? (and why...)

1763 *Family Feud* or *Jeopardy*? (and why...)

1764 SoHo or Chelsea? (and why...)

1765 Latitude or longitude? (and why...)

1766 French or Dutch braid? (and why...)

1767 Maid or housekeeper? (and why...)

1768 *101 Dalmatians* or *Lady and the Tramp*? (and why...)

1769 Living Social or Groupon? (and why...)

1770 Matches or lighter? (and why...)

1771 Kimono or Karategi? (and why...)

1772 *The Breakfast Club* or *Sixteen Candles*? (and why...)

1773 Peeps or cotton candy? (and why...)

1774 Universe or galaxy? (and why...)

1775 Thyme or rosemary? (and why...)

1776 Leather or microfiber sofa? (and why...)

1777 Baggy or tight jeans? (and why...)

1778 Cut corners or cut the mustard? (and why...)

1779 Manatee or beluga whale? (and why...)

1780 Secret Santa or White elephant? (and why...)

1781 Montezuma's revenge or food poisoning? (and why...)

1782 Devil's Island or Alcatraz? (and why...)

1783 London Eye or Space Needle? (and why...)

1784 Ostrich or quail eggs? (and why...)

1785 Weekly or biweekly paychecks? (and why...)

1786 Fiat or Mini Cooper? (and why...)

1787 Car or insurance salesperson? (and why...)

1788 Flamboyant or flagrant? (and why...)

1789 Kazoo or clarinet? (and why...)

1790 Hibachi or Shabu Shabu? (and why...)

1791 Loose or fitted shirts? (and why...)

1792 Glaze or sauce? (and why...)

1793 Pico de gallo or chimichurri? (and why...)

1794 Yearbook club or student council? (and why...)

1795 Gothic or Emo? (and why...)

1796 Raw or steamed veggies? (and why...)

1797 WikiHow or eHow? (and why...)

1798 Mashable or BuzzFeed? (and why...)

1799 Arnold Palmer or Roy Rogers mocktail? (and why...)

1800 Moth to a flame or curiosity killed the cat? (and why...)

1801 Count sheep or 4-7-8 breathing? (and why...)

1802 Coast Guard or Air Force? (and why...)

1803 Second chance or no chance? (and why...)

1804 Combination or key lock? (and why...)

1805 Quail or Cornish hens? (and why...)

1806 Cast iron or non-stick skillet? (and why...)

1807 Cannoli or baklava? (and why...)

1808 Downward-facing dog or eagle pose? (and why...)

1809 Sno Ball or Zinger? (and why...)

1810 Irony or oxymoron? (and why...)

1811 Rice Chex or Rice Krispies? (and why...)

1812 Redwood or dogwood tree? (and why...)

1813 Oscar Meyer Wieners or Nathan's Franks? (and why...)

1814 Tai Chi or Qigong? (and why...)

1815 Mole or birthmark? (and why...)

1816 Yodel or croon? (and why...)

1817 Shag or frieze carpet? (and why...)

1818 Teepee or igloo? (and why...)

1819 Fleece or terry cloth robe? (and why...)

1820 Nun chucks or throwing stars? (and why...)

1821 Gouda or goat cheese? (and why...)

1822 Allegory or alliteration? (and why...)

1823 Jerky or Slim Jim? (and why...)

1824 Exfoliate or moisturize? (and why...)

1825 Boogie board or wakeboard? (and why...)

1826 Second nature or second guess? (and why...)

1827 Dubble Bubble or Trident gum? (and why...)

1828 Cards Against Humanity or Never Have I Ever? (and why...)

1829 PEZ or Smarties? (and why...)

1830 Love Connection or Newlywed Game? (and why...)

1831 Lucky Charms or Apple Jacks? (and why...)

1832 Refurbish furniture or restore a car? (and why...)

1833 Air guitar or air drums? (and why...)

1834 Cake pop or cupcake? (and why...)

1835 Right brain or left brain? (and why...)

1836 Road rash or sunburn? (and why...)

1837 Faithful or unfaithful? (and why...)

1838 Nursing home or daycare? (and why...)

1839 Dim or bright lights? (and why...)

1840 Edison or energy saver light bulbs? (and why...)

1841 DiGiorno or Totino's frozen pizza? (and why...)

1842 Marble or granite countertops? (and why...)

1843 Defend or attack? (and why...)

1844 Your enemy or the enemy of your enemy? (and why...)

1845 Sip or swig? (and why...)

1846 Jupiter or Saturn? (and why...)

1847 Hippocrates or Sigmund Freud? (and why...)

1848 Houndstooth or pin stripe fabric? (and why...)

1849 Gallop or trot? (and why...)

1850 Handstand or backbend? (and why...)

1851 Country club or beach club? (and why...)

1852 Jamaica or Belize? (and why...)

1853 Grotto or cavern? (and why...)

1854 Gem hunting or panning for gold? (and why...)

1855 Feather boa or dog collar? (and why...)

1856 Socrates or Aristotle? (and why...)

1857 Outshine or overshadow? (and why...)

1858 Pearl Jam or Nirvana? (and why...)

1859 MENSA or Toastmasters? (and why...)

1860 Claustrophobia or acrophobia? (and why...)

1861 Lost at sea or stranded in the desert? (and why...)

1862 . Special delivery or handle with care? (and why...)

1863 Establish or reinvent? (and why...)

1864 Golden Retriever or Great Dane? (and why...)

1865 *Master of Disguise* or *Master of Illusion*? (and why...)

1866 Revenge or pardon? (and why...)

1867 Tiffany & Co. or Harry Winston? (and why...)

1868 Potato pancakes or hash browns? (and why...)

1869 Beauty mark or dimples? (and why...)

1870 Google or Yahoo? (and why...)

1871 Globetrotter or home body? (and why...)

1872 Pig out or diet? (and why...)

1873 Tea or cocktail party? (and why...)

1874 *In Style* or *Entertainment Weekly*? (and why...)

1875 Bono or Ringo? (and why...)

1876 Spoil or neglect? (and why...)

1877 Fire fighter or police officer? (and why...)

1878 Ask.com or Bing? (and why...)

1879 Mullholland Drive or Sunset Strip? (and why...)

1880 *Mortal Kombat* or *Street Fighter*? (and why...)

1881 Bellagio or MGM Grand? (and why...)

1882 Affirmations or declarations? (and why...)

1883 Scrabble or Yahtzee? (and why...)

1884 Nintendo or Sega? (and why...)

1885 Local or international? (and why...)

1886 Bangs or no bangs (hair)? (and why...)

1887 A&W or IBC root beer? (and why...)

1888 Caffeinated or caffeine-free? (and why...)

1889 Tickle or wrestle? (and why...)

1890 Hand gestures or body language? (and why...)

1891 Planet Hollywood or Hard Rock Café? (and why...)

1892 Joshua Tree or Death Valley? (and why...)

1893 Universal Studios or Sea World? (and why...)

1894 Student loans or credit card debt? (and why...)

1895 Big feet or big ears? (and why...)

1896 Street cable car or aerial tramway? (and why...)

1897 Buffalo or black bean burger? (and why...)

1898 Heinz 57 or A1 sauce? (and why...)

1899 Protein or fiber? (and why...)

1900 Horseshoes or croquette? (and why...)

1901 Foolish or dumbfounded? (and why...)

1902 Contract or freelance? (and why...)

1903 Mahogany or oak? (and why...)

1904 *Little Red Riding Hood* or *The Ugly Duckling*? (and why...)

1905 Square or figure 8 knot? (and why...)

1906 Witness or alibi? (and why...)

1907 Charlotte's Web or Ferdinand the Bull? (and why...)

1908 The Who or The Doors? (and why...)

1909 Knights of the Round Table or knight in shining armor? (and why...)

1910 The Osbournes or The Kardashians? (and why...)

1911 Oceans 11 or 12? (and why...)

1912 *The Addams Family* or *The Munsters*? (and why...)

1913 Minecraft or League of Legends? (and why...)

1914 One pound of quarters or two pounds of dimes? (and why...)

1915 Tactical or strategist? (and why...)

1916 Thief or liar? (and why...)

1917 Wings or jetpack? (and why...)

1918 Invisibility or teleportation? (and why...)

1919 Merciful or merciless? (and why...)

1920 Guess who or guess what? (and why...)

1921 Pale or tan? (and why...)

1922 Knight or Duke? (and why...)

1923 Emotionally or physically drained? (and why...)

1924 Biggie or Tupac? (and why...)

1925 Feared or respected? (and why...)

1926 JC Penney or Kohl's? (and why...)

1927 Bankrupt or humiliated? (and why...)

1928 Airhorn or referee whistle? (and why...)

1929 Dick's or Academy Sports + Outdoors? (and why...)

1930 Wells Fargo or Chase? (and why...)

1931 Nemesis or associate? (and why...)

1932 Shape up or ship out? (and why...)

1933 *Real Housewives of New York* or *Real Housewives of Atlanta*? (and why...)

1934 Secret language or secret society? (and why...)

1935 AMC or FX? (and why...)

1936 Rotten Tomatoes or IMDB? (and why...)

1937 Quora or Wikipedia? (and why...)

1938 Panhandle or homeless? (and why...)

1939 Plan A or B? (and why...)

1940 Multiple choice or true/false questions? (and why...)

1941 Under Armor or Luluemon Athletica? (and why...)

1942 *Pretty Little Liars* or *Vampire Dairies*? (and why...)

1943 MIT or Caltech? (and why...)

1944 Welcome to the Jungle or Paradise City? (and why...)

1945 Canada or Mexico? (and why...)

1946 Ace in the hole or piece of cake? (and why...)

1947 Strict or lax parenting? (and why...)

1948 Venture capitalist or angel investor? (and why...)

1949 Discount or bargain? (and why...)

1950 Tapioca or banana pudding? (and why...)

1951 Toxic or jaded? (and why...)

1952 Sara Lee or Pepperidge Farms? (and why...)

1953 Six inch or footlong Subway? (and why...)

1954 Electric chair or lethal injection? (and why...)

1955 Die quickly or die slowly? (and why...)

1956 Now or then? (and why...)

1957 Matthew McConaughey or Matt Damon? (and why...)

1958 Leggings or jeggings? (and why...)

1959 Bert and Ernie or Beavis and Butthead? (and why...)

1960 Hunger or thirst? (and why...)

1961 *Walking Dead* or *Breaking Bad*? (and why...)

1962 Chisel or carve? (and why...)

1963 Asian or Bartlett pear? (and why...)

1964 Artemis or Athena? (and why...)

1965 Fizzy or bubbly? (and why...)

1966 Glove box or center console? (and why...)

1967 House of Cards or Jenga? (and why...)

1968 Pillow or food fight? (and why...)

1969 Toothache or fever blister? (and why...)

1970 Environment or economy? (and why...)

1971 Beyoncé or Janet Jackson? (and why...)

1972 Nosey or pushy? (and why...)

1973 World domination or world peace? (and why...)

1974 101 questions or 99 problems? (and why...)

1975 Serenity or chaos? (and why...)

1976 Milestones or achievements? (and why...)

1977 Super Girl or Cat Woman? (and why...)

1978 Daily or weekly? (and why...)

1979 Driving or fingerless gloves? (and why...)

1980 Fenway Park or Yankee Stadium? (and why...)

1981 Pizza delivery driver or Uber driver? (and why...)

1982 Blindfolded or handcuffed? (and why...)

1983 Spiderweb or beehive? (and why...)

1984 Journalist or editor? (and why...)

1985 Travel Channel or Food Network? (and why...)

1986 *Flashdance* or *Fame*? (and why...)

1987 Poach or sauté? (and why...)

1988 Spacious or compact? (and why...)

1989 Tiramisu or tres leches cake? (and why...)

1990 *Chronicles of Narnia* or *Spiderwick Chronicles*? (and why...)

1991 Sundance or Cannes Film Festival? (and why...)

1992 Stunned or startled? (and why...)

1993 Biceps or triceps? (and why...)

1994 Capitalist or idealist? (and why...)

1995 Opposites attract or match made in heaven? (and why...)

1996 Colleague or co-worker? (and why...)

1997 Choreographer or ballet dancer? (and why...)

1998 Leg press or bench press? (and why...)

1999 Coach or teacher? (and why...)

2000 Tease or taunt? (and why...)

2001 Boston Red Sox or New York Yankees? (and why...)

2002 Dirty jokes or knock-knock jokes? (and why...)

2003 Cyclist or runner? (and why...)

2004 Boardwalk or Park Place? (and why...)

2005 Want or desire? (and why...)

2006 Cupid or Eros? (and why...)

2007 Personal trainer or fitness instructor? (and why...)

2008 Quad or calves? (and why...)

2009 Widowed or divorced? (and why...)

2010 Transparent or vague? (and why...)

2011 Limestone or sandstone? (and why...)

2012 Photographer or videographer? (and why...)

2013 Dallas Cowboys or New England Patriots? (and why...)

2014 Embroider or engrave? (and why...)

2015 Funeral or wedding? (and why...)

2016 Insult or compliment? (and why...)

2017 Coincidence or divergence? (and why...)

2018 Baked Alaska or fried ice cream? (and why...)

2019 Grasshopper or cricket? (and why...)

2020 Win an argument or have the last word? (and why...)

2021 Wishing well or wish upon a star? (and why...)

2022 Nihilist or opportunist? (and why...)

2023 Dilemma or quandary? (and why...)

2024 Four leaf clover or rabbit's foot? (and why...)

2025 Bored or bewildered? (and why...)

2026 Quantum leap or metamorphosis? (and why...)

2027 Lecture or sermon? (and why...)

2028 National Spelling Bee or Westminster Dog Show? (and why...)

2029 Hamptons or Carmel by the Sea? (and why...)

2030 Campbell's or Progresso soup? (and why...)

2031 Baba ghanoush or tabbouleh? (and why...)

2032 *The West Wing* or *House of Cards*? (and why...)

2033 Naughty or nice? (and why...)

2034 Improvise or prepare? (and why...)

2035 Volcanic eruption or earthquake? (and why...)

2036 Black Friday or Cyber Monday? (and why...)

2037 Suntan oil or lotion? (and why...)

2038 Sugar or salt body scrub? (and why...)

2039 Chihuahua or dachshund? (and why...)

2040 Please or thank you? (and why...)

2041 Sphynx or Persian cat? (and why...)

2042 Stutter or lisp? (and why...)

2043 Bacteria or viral infection? (and why...)

2044 King or snow crab? (and why...)

2045 *Austin Powers* or *The Godfather Trilogy?* (and why...)

2046 Notebook or tablet? (and why...)

2047 Thesaurus or dictionary? (and why...)

2048 Jazzercise or water aerobics? (and why...)

2049 Bermuda shorts or boardshorts? (and why...)

2050 Emperor or Sultan? (and why...)

2051 Big Red or Mountain Dew? (and why...)

2052 Edamame or chickpeas? (and why...)

2053 Good luck or best wishes? (and why...)

2054 Get well soon or sympathy card? (and why...)

2055 Slim Shady or Ziggy Stardust? (and why...)

2056 Fendi or Gucci? (and why...)

2057 Wide or narrow feet? (and why...)

2058 Wolfgang Puck or Julia Child? (and why...)

2059 Leaf or snow blower? (and why...)

2060 Jelly donut or apple fritter? (and why...)

2061 B12 or B6? (and why...)

2062 Slot machine or flying cash cube? (and why...)

2063 Laughing Cow or Babybel cheese? (and why...)

2064 Pillsbury Doughboy or Jolly Green Giant? (and why...)

2065 *Hunger Games* or *The Maze Runner*? (and why...)

2066 Coconut or chocolate cream pie? (and why...)

2067 Pie or cake? (and why...)

2068 Famous Amos or Nestle Toll House cookies? (and why...)

2069 Death penalty or life in prison? (and why...)

2070 Vaulted or flat ceilings? (and why...)

2071 Stepmother or mother-in-law? (and why...)

2072 Bodyguard or bouncer? (and why...)

2073 Dude ranch or farmhouse? (and why...)

2074 Public display of affection (PDA): always or never? (and why...)

2075 Snapple or Lipton tea? (and why...)

2076 Space travel or time travel? (and why...)

2077 Panera or Chipotle? (and why...)

2078 Man in the Mirror or Billie Jean? (and why...)

2079 #TransformationTuesday or #ThrowbackThursday? (and why...)

2080 NyQuil or DayQuil? (and why...)

2081 Earwax or boogers? (and why...)

2082 Rachael Ray or Giada De Laurentiis? (and why...)

2083 The Alchemist or Animal Farm? (and why...)

2084 French Roast or Columbian coffee? (and why...)

2085 Dunk tank or kissing booth? (and why...)

2086 Ceramics or pottery? (and why...)

2087 Taurus or Capricorn? (and why...)

2088 Bowler or Panama hat? (and why...)

2089 Folk or Indie music? (and why...)

2090 Coconut water or juice? (and why...)

2091 iTunes or Google Play? (and why...)

2092 Hedge your bet or bet your bottom dollar? (and why...)

2093 The White House or The Pentagon? (and why...)

2094 Alexander the Great or Genghis Khan? (and why...)

2095 Second-guess or up the ante? (and why...)

2096 Hatchback or trunk? (and why...)

2097 *Psycho* or *The Birds*? (and why...)

2098 Walk along the beach or walk in the woods? (and why...)

2099 Dark horse or underdog? (and why...)

2100 Scapegoat or save face? (and why...)

2101 Muffin top or six pack? (and why...)

2102 Trivia or game night? (and why...)

2103 Bar or pub? (and why...)

2104 Scaredy cat or bold as a lion? (and why...)

2105 Read between the lines or read the riot act? (and why...)

2106 Poncho or wrap? (and why...)

2107 Hope chest or steamer trunk? (and why...)

2108 Zagat Survey or Census? (and why...)

2109 Clone or regeneration? (and why...)

2110 Hand or foot break? (and why...)

2111 Singles or doubles tennis? (and why...)

2112 Chewy or dense? (and why...)

2113 Curd or custard? (and why...)

2114 Strain or sprain a muscle? (and why...)

2115 Whistleblower or snitch? (and why...)

2116 Tumblr or WordPress? (and why...)

2117 Coco Puffs or Kix cereal? (and why...)

2118 Whack-A-Mole or ring toss? (and why...)

2119 Simon or Bop-it? (and why...)

2120 *Guardians of the Galaxy* or *Avengers: Infinity War?* (and why...)

2121 Registered nurse or OR nurse? (and why...)

2122 WhatsApp or Facebook messenger? (and why...)

2123 Soup or salad? (and why...)

2124 Fresh or frozen? (and why...)

2125 Jane Eyre or Vanity Fair novel? (and why...)

2126 Lapse in judgement or trust your judgement? (and why...)

2127 Mary Janes or Oxfords? (and why...)

2128 Hives or chickenpox? (and why...)

2129 Game changer or play by the rules? (and why...)

2130 *Sports Illustrated* or *Good Housekeeping?* (and why...)

2131 Wrinkles or warts? (and why...)

2132 Tassels or beads? (and why...)

2133 Monocle or magnifying glass? (and why...)

2134 Saga or tale? (and why...)

2135 Blackout or sheer curtains? (and why...)

2136 Christmas or Halloween party? (and why...)

2137 Michael Kors or Marc Jacobs? (and why...)

2138 *Pandora* or *Sleepy Hollow?* (and why...)

2139 Häagen-Dazs or Ben & Jerry's? (and why...)

2140 Tea tree or eucalyptus oil? (and why...)

2141 *South Park* or *Futurama?* (and why...)

2142 Square dancing or polka dancing? (and why...)

2143 Guard your heart or watch your mouth? (and why...)

2144 *The Nightmare Before Christmas* or *The Polar Express?* (and why...)

2145 Team building or icebreaker activities? (and why...)

2146 Meatballs or fish balls? (and why...)

2147 Maiden's or Warwick Castle? (and why...)

2148 Alien abduction or invasion? (and why...)

2149 Work alone or work in a group? (and why...)

2150 Vera Wang or Zac Posen? (and why...)

2151 Dates or raisins? (and why...)

2152 Morning or evening workout? (and why...)

2153 Bikini Bottom or Who-ville? (and why...)

2154 Christie's or Sotheby's Auctions? (and why...)

2155 Two or three-layer cake? (and why...)

2156 Chanterelle or cremini mushroom? (and why...)

2157 Quentin Tarantino or Tim Burton? (and why...)

2158 Egg or bubble chair? (and why...)

2159 Beverly Hills Hotel or The Plaza? (and why...)

2160 Row machine or spinning bike? (and why...)

2161 Surf: Longboard or shortboard? (and why...)

2162 Pierce Brosnan or Roger Moore or Sean Connery as 007? (and why...)

2163 Metropolis or Gotham? (and why...)

2164 Summer vacation or winter break? (and why...)

2165 Procrastinate or finish early? (and why...)

2166 Exercise ball or ab wheel? (and why...)

2167 Trust-building or self-awareness exercises? (and why...)

2168 Adopt a highway or adopt a classroom? (and why...)

2169 Block or unfollow? (and why...)

2170 Animal shelter or food pantry? (and why...)

2171 Head over heels or heads up? (and why...)

2172 Microsoft Word or Google Docs? (and why...)

2173 Chevy Malibu or Impala? (and why...)

2174 Igor or Dr. Watson? (and why...)

2175 *The Mary Tyler Moore* or *Carol Burnett Show?* (and why...)

2176 Most dangerous or worst job of all-time? (and why...)

2177 *Beetlejuice* or *Sweeney Todd*? (and why...)

2178 Anthology or novel? (and why...)

2179 Free online class or free samples? (and why...)

2180 Jack of all trades or master of one? (and why...)

2181 Michael Keaton or Ben Affleck as Batman? (and why...)

2182 Grumpy Cat or Lil Bub? (and why...)

2183 Open mic night or poetry slam? (and why...)

2184 Track and field or golf? (and why...)

2185 Jasper or agate stone? (and why...)

2186 Seychelles or Maldives? (and why...)

2187 *School House Rock* or *Mister Rogers Neighborhood*? (and why...)

2188 Bernina Express or Train to the Clouds? (and why...)

2189 Betty White or Bob Newhart? (and why...)

2190 Tavern on the Green or Delmonico's? (and why...)

2191 *Charlie's Angels* or *Mod Squad*? (and why...)

2192 Transylvania or Prague? (and why...)

2193 Muk Luks or Uggs? (and why...)

2194 Physical or imaginative journey? (and why...)

2195 Revival or rebirth? (and why...)

2196 Flared or straight-legged pants? (and why...)

2197 Swallow your gum or gum in your hair? (and why...)

2198 Honeydew or bitter melon? (and why...)

2199 Jimmy Choo or Manolo Blahnik? (and why...)

2200 Jay or Silent Bob? (and why...)

2201 The land of nod or sawing logs? (and why...)

2202 Mister Sandman or The Tooth Fairy? (and why...)

2203 Self-driving car or person operated car? (and why...)

2204 Rent or own? (and why...)

2205 Online or brick and mortar store? (and why...)

2206 Halo or horns? (and why...)

2207 Dust or ashes? (and why...)

2208 Linger or dwell? (and why...)

2209 Toadstool or lily pad? (and why...)

2210 Cherub or gargoyle? (and why...)

2211 Roadie or groupie? (and why...)

2212 Someday or right now? (and why...)

2213 Food truck or ice cream truck? (and why...)

2214 Natural or acrylic nails? (and why...)

2215 Long or thick eyelashes? (and why...)

2216 Fashion statement or political statement? (and why...)

2217 Lasting impression or first impression? (and why...)

2218 Thumb or arm wrestle? (and why...)

2219 Shoot for the moon or reach for the stars? (and why...)

2220 Level headed or hot headed? (and why...)

2221 Climax or cliffhanger? (and why...)

2222 Type or text fast? (and why...)

2223 LOL or ROTFL? (and why...)

2224 Tailgate or beer pong? (and why...)

2225 Accept or resist change? (and why...)

2226 TTYL or BRB? (and why...)

2227 Corn beef or pot roast? (and why...)

2228 Space or summer camp? (and why...)

2229 Matriarch or patriarch? (and why...)

2230 OMG or WTF? (and why...)

2231 Monogamy: yes or no? (and why...)

2232 Anteater or aardvark? (and why...)

2233 Baby back or spare ribs? (and why...)

2234 Laser focused or scatter brained? (and why...)

2235 Tinker Bell or fairy godmother? (and why...)

2236 Perfectionist or non-perfectionist? (and why...)

2237 Lemony Snicket or J.K. Rowling? (and why...)

2238 Helping hand or hand out? (and why...)

2239 Civil or criminal juror? (and why...)

2240 *When Harry Met Sally* or *Sleepless in Seattle?* (and why...)

2241 Fruit cocktail or mandarin oranges? (and why...)

2242 Pokémon or Digimon? (and why...)

2243 Flan or bread pudding? (and why...)

2244 Ingrown nail or nail fungus? (and why...)

2245 Pictionary or Bananagrams? (and why...)

2246 *Hell's Kitchen* or *Master Chef?* (and why...)

2247 Neutrogena or Aveeno? (and why...)

2248 Good Humor or Skinny Cow? (and why...)

2249 Sandra Bullock or Jennifer Aniston? (and why...)

2250 Shepherds pie or pot pie? (and why...)

2251 Pot stickers or perogies? (and why...)

2252 Cruller or powdered donut? (and why...)

2253 Ork or Gollum? (and why...)

2254 Rolaids or Tums? (and why...)

2255 Cranium or Sorry? (and why...)

2256 Field or ice hockey? (and why...)

2257 Google Maps or Waze? (and why...)

2258 Red velvet cake or carrot cake? (and why...)

2259 Boston cream pie or cream puffs? (and why...)

2260 Bubble bath or detox bath? (and why...)

2261 Tim Hortons or Krispy Kreme? (and why...)

2262 White or gray hair? (and why...)

2263 Klondike bar or fudgsicle? (and why...)

2264 Chicken parmesan or chicken cordon bleu? (and why...)

2265 Clay or mud facemask? (and why...)

2266 Mild or sharp cheddar cheese? (and why...)

2267 Thanksgiving dressing or stuffing? (and why...)

2268 Creamed corn or creamed spinach? (and why...)

2269 MAC or NARS? (and why...)

2270 Spring or distilled water? (and why...)

2271 Noxzema or Clearasil? (and why...)

2272 Dashing or rugged? (and why...)

2273 Debutante or diva? (and why...)

2274 Gala or banquet? (and why...)

2275 Ice fishing or noodling? (and why...)

2276 Catered or potluck? (and why...)

2277 Airplane or hospital food? (and why...)

2278 Rockefeller Center or Times Square? (and why...)

2279 Coney Island or Myrtle Beach Boardwalk? (and why...)

2280 Sia or Lady Gaga? (and why...)

2281 Paralegal or dental assistant? (and why...)

2282 Wicked Witch of the West or Glinda the Good Witch? (and why...)

2283 Venice Beach or Malibu? (and why...)

2284 Albus Dumbledore or Gandalf? (and why...)

2285 Sequels or trilogies? (and why...)

2286 *Jaws* or *Open Water*? (and why...)

2287 Part-time or full-time job? (and why...)

2288 Nanny or personal shopper? (and why...)

2289 Embalmer or taxidermist? (and why...)

2290 Silence is golden or the golden rule? (and why...)

2291 Hush puppies or cornbread? (and why...)

2292 KFC: crispy or original recipe? (and why...)

2293 Beer batter or cornmeal? (and why...)

2294 Highland or Holstein cow? (and why...)

2295 Popcorn shrimp or tiger prawns? (and why...)

2296 Honey butter or garlic butter? (and why...)

2297 Red Lobster or Cracker Barrel biscuits? (and why...)

2298 Floppy sun hat or tennis visor? (and why...)

2299 Touchdown or homerun? (and why...)

2300 Ralph Lauren or Tommy Hilfiger? (and why...)

2301 Gray or blue skies? (and why...)

2302 *Brady Bunch* or *Married with Children*? (and why...)

2303 Urban Decay or Bobbi Brown? (and why...)

2304 Seven-layer dip or seven-layer bars? (and why...)

2305 Potato skins or stuffed peppers? (and why...)

2306 Cutting board or cheese board? (and why...)

2307 Sticky or honey buns? (and why...)

2308 American Eagle or Abercrombie & Fitch? (and why...)

2309 Navy or powder blue? (and why...)

2310 Hawaiian Punch or Hi-C? (and why...)

2311 Mongolian or Szechwan beef? (and why...)

2312 Dairy Queen or Jack-in-the Box? (and why...)

2313 Pistachio or butter pecan ice cream? (and why...)

2314 Maki or hand roll sushi? (and why...)

2315 Sweet potato or zucchini noodles? (and why...)

2316 Bruschetta or canape? (and why...)

2317 Butterfinger or Payday? (and why...)

2318 Estée Lauder or Clinique? (and why...)

2319 Shell or Chevron? (and why...)

2320 Vegetable or fruit pizza? (and why...)

2321 L.L. Bean or The North Face? (and why...)

2322 Crimson or garnet? (and why...)

2323 Whale watching or cage dive with white sharks? (and why...)

2324 #TacoTuesday or #MeatlessMonday? (and why...)

2325 Wet wipes or toilet paper? (and why...)

2326 Hollister or Aeropostale? (and why...)

2327 All Recipes or Yummly? (and why...)

2328 Give a cold shoulder or taste of their own medicine? (and why...)

2329 Health or wealth? (and why...)

2330 Parking or traffic ticket? (and why...)

2331 Laser or inkjet printer? (and why...)

2332 Al Pacino or Robert De Niro? (and why...)

2333 Public speaker or life coach? (and why...)

2334 Hamburger Helper or Dinty Moore? (and why...)

2335 Design or decorate? (and why...)

2336 Arugula or watercress? (and why...)

2337 New England or Manhattan clam chowder? (and why...)

2338 Matzo or graham crackers? (and why...)

2339 Monkey business or rat race? (and why...)

2340 Tide or Gain detergent? (and why...)

2341 Feta or blue cheese? (and why...)

2342 English or Persian cucumber? (and why...)

2343 Work in progress or work of art? (and why...)

2344 Steel cut or old-fashioned oatmeal? (and why...)

2345 Pumpkin or pecan pie? (and why...)

2346 Eat crow or hit below the belt? (and why...)

2347 Top dog or eager beaver? (and why...)

2348 Love handles or bread basket? (and why...)

2349 The name game or tongue twisters? (and why...)

2350 Fritos or Fritos Scoops? (and why...)

2351 Keebler or Nabisco? (and why...)

2352 Chase rainbows or head in the clouds? (and why...)

2353 Gazpacho or minestrone? (and why...)

2354 Eye catching or turn a blind eye? (and why...)

2355 Waldorf or pasta salad? (and why...)

2356 Golden opportunity or cash cow? (and why...)

2357 Butternut or spaghetti squash? (and why...)

2358 Tough cookie or egg head? (and why...)

2359 Internist or nutritionist? (and why...)

2360 Puppy love or love on the rocks? (and why...)

2361 Ironman or Spiderman? (and why...)

2362 Steve Martin or Martin Short? (and why...)

2363 Maxi dress or mini skirt? (and why...)

2364 Home office or home theatre? (and why...)

2365 Duck face or kissy face? (and why...)

2366 *Mob Wives* or *Basketball Wives*? (and why...)

2367 More courage or more confidence? (and why...)

2368 Nashville or Austin? (and why...)

2369 BBQ or fried chicken? (and why...)

2370 *1984* or *Ghostbusters*? (and why...)

2371 Wheat or cauliflower pizza crust? (and why...)

2372 When pigs fly or when hell freezes over? (and why...)

2373 Love is blind or love is patient? (and why...)

2374 Downtown or uptown? (and why...)

2375 Lap of luxury or modest accommodations? (and why...)

2376 Film noir or German expressionism? (and why...)

2377 Corsage or boutonniere? (and why...)

2378 Pick flowers or pick berries? (and why...)

2379 Chutes and Ladders or Mouse Trap? (and why...)

2380 The Jonas or Hemsworth brothers? (and why...)

2381 Common sense or book smart? (and why...)

2382 Wolf or vampire bite? (and why...)

2383 Artichoke hearts or hearts of palm? (and why...)

2384 Melba toast or croutons? (and why...)

2385 Duck boots or riding boots? (and why...)

2386 Amethyst or aquamarine? (and why...)

2387 Marvin the Martian or Invader Zim? (and why...)

2388 Supernatural or Agents of S.H.I.E.L.D.? (and why...)

2389 Night vision or X-ray vision? (and why...)

2390 Stuffed animals or action figures? (and why...)

2391 Animal cookies or cheese crackers? (and why...)

2392 Hot chocolate or chocolate milk? (and why...)

2393 Monty Python or SNL? (and why...)

2394 Plan a road trip or party? (and why...)

2395 Walk the walk or talk the talk? (and why...)

2396 Natural look or makeup? (and why...)

2397 Tie-dye: in or out? (and why...)

2398 Stand-up or sit-down desk? (and why...)

2399 *Halloween* or *Friday the 13th* movie? (and why...)

2400 Heathcliff or Darcy? (and why...)

2401 New pair of jeans or new pair of shoes? (and why...)

2402 Bowflex or ThighMaster? (and why...)

2403 Would you rather or icebreaker questions? (and why...)

2404 Day off: Monday or Saturday? (and why...)

2405 Big Fish or Wild Tangent Games? (and why...)

2406 No more stress or sadness? (and why...)

2407 Blow bubbles or dandelions? (and why...)

2408 Relentless or prudent? (and why...)

2409 Direct or produce? (and why...)

2410 Outdoor or indoor security cameras? (and why...)

2411 Random stranger or your ex? (and why...)

2412 Wink or blow kisses? (and why...)

2413 Infomercials: love or hate? (and why...)

2414 Wedding planner: yes or no? (and why...)

2415 Fire extinguisher or smoke detector? (and why...)

2416 HSN or QVC? (and why...)

2417 Cronut or brookie? (and why...)

2418 Ban smoking or drinking? (and why...)

2419 *Who Wants to Be a Millionaire* or *Hollywood Game Night*? (and why...)

2420 Banking apps: yes or no? (and why...)

2421 Diner Dash or Cooking Dash? (and why...)

2422 Apple of my eye or bee's knees? (and why...)

2423 Horseback riding or swim with dolphins? (and why...)

2424 Watercolor or oil paintings? (and why...)

2425 Skippy or Jif peanut butter? (and why...)

2426 *America's Next Top Model* or *Project Runway*? (and why...)

2427 Live Nation or Stub Hub? (and why...)

2428 *Shaun of the Dead* or *Zombieland*? (and why...)

2429 Happy meal or Lunchable? (and why...)

2430 House of Blues or Medieval Times? (and why...)

2431 St. Peter's Basilica or St. Basil's Cathedral? (and why...)

2432 Warner or Universal Music Group? (and why...)

2433 10 or 20 years in the future? (and why...)

2434 Notre Dame or Purdue? (and why...)

2435 *Scream* or *I Know What You Did Last Summer?* (and why...)

2436 Sell or buy real estate? (and why...)

2437 *Girls* or *Sex and the City?* (and why...)

2438 Carrots or parsnips? (and why...)

2439 Walking on sunshine or a pocket full of sunshine? (and why...)

2440 Cheesy or corny? (and why...)

2441 Piece of cake or easy as pie? (and why...)

2442 JBL or Sonos speakers? (and why...)

2443 *Downton Abby* or *Doctor Who?* (and why...)

2444 Ice cream maker or waffle iron? (and why...)

2445 Shonda Rhymes or Dick Wolf? (and why...)

2446 *Shark Tank* or *The Profit*? (and why...)

2447 *The Bachelor* or *The Bachelorette*? (and why...)

2448 Wildlife or land conservancy? (and why...)

2449 Blow smoke or beat around the bush? (and why...)

2450 Drake or Big Sean? (and why...)

2451 Politically correct: sometimes, always or never? (and why...)

2452 Change or growth? (and why...)

2453 Rosa Parks or Harriet Tubman? (and why...)

2454 Chicken or steak fingers? (and why...)

2455 50 Cents or 2 Chainz? (and why...)

2456 Audible books: yes or no? (and why...)

2457 Alfred Pennyworth or Pepper Pots? (and why...)

2458 *Cosmopolitan* or *Harper's Bazaar*? (and why...)

2459 Gloria Allrad or Gloria Steinem? (and why...)

2460 Food processor or rice cooker? (and why...)

2461 Wristbands: yes or no? (and why...)

2462 Funny memes or viral videos? (and why...)

2463 Cotton Bowl or Rose Bowl? (and why...)

2464 Tug of war or potato sack race? (and why...)

2465 All ears or on the ball? (and why...)

2466 Rice or potatoes? (and why...)

2467 Keep the faith or tie a knot at the end of your rope and hang on? (and why...)

2468 Indulge or moderate? (and why...)

2469 Fruity Pebbles or Cocoa Pebbles? (and why...)

2470 Lois Lane or Vicki Vale? (and why...)

2471 Humphrey Bogart or Cary Grant? (and why...)

2472 Betty Crocker or Duncan Heinz? (and why...)

2473 Velveeta or Kraft cheese? (and why...)

2474 Pistachio or macadamia nuts? (and why...)

2475 Vanilla bean or bittersweet? (and why...)

2476 5 second rule: yes or no? (and why...)

2477 Deepak Chopra or Zig Ziglar? (and why...)

2478 Arbor Day or Earth Day? (and why...)

2479 *The Power of Positive Thinking* or *The Power of Now*? (and why...)

2480 Neil Armstrong or Buzz Aldrin? (and why...)

2481 U.S. Open or French Open? (and why...)

2482 Wayne Dyer or Paulo Coelho? (and why...)

2483 Front loader or top loader washing machine? (and why...)

2484 Hold hands or arm in arm? (and why...)

2485 Immune boost or mood boost? (and why...)

2486 JFK or RFK? (and why...)

2487 RITZ or Goldfish crackers? (and why...)

2488 Face paced or slow and steady? (and why...)

2489 Grace Kelly or Princess Diana? (and why...)

2490 Thin line between love and hate or kiss and make up? (and why...)

2491 Life goes on or time heals all wounds? (and why...)

2492 *The Princess Diaries* or *The Princess Bride*? (and why...)

2493 More followers on Instagram or more friends on Facebook? (and why...)

2494 Bubble gum or sunflower seeds? (and why...)

2495 Fever blister or chapped lips? (and why...)

2496 Dry skin or oily hair? (and why...)

2497 Box office hits or cult classics? (and why...)

2498 Sleep alone or cuddle buddy? (and why...)

2499 Healthy Choice or Lean Cuisine? (and why...)

2500 Risotto or gnocchi? (and why...)

2501 Cable or satellite? (and why...)

2502 Squash or pickleball? (and why...)

2503 Endure or overcome? (and why...)

2504 Spring or fall? (and why...)

2505 Hotel or motel? (and why...)

2506 Fan or aficionado? (and why...)

2507 Complain or compliment? (and why...)

2508 *Beauty and the Beast* or *Sleeping Beauty*? (and why...)

2509 Proverb or myth? (and why...)

2510 Parable or fable? (and why...)

2511 Lame or limp? (and why...)

2512 Touch or taste? (and why...)

2513 Rave or house party? (and why...)

2514 Head above water or staying afloat? (and why...)

2515 Stir the pot or put out fires? (and why...)

2516 Musically or mechanically inclined? (and why...)

2517 Plain or peanut M&M's? (and why...)

2518 Backstreet Boys or NSYNC? (and why...)

2519 *Dora the Explorer* or *Carmen Sandiego*? (and why...)

2520 Push the limits or quit while you're ahead? (and why...)

2521 Poetic justice or justice is blind? (and why...)

2522 House or electronic music? (and why...)

2523 Downy or Snuggle? (and why...)

2524 Nature lover or tree-hugger? (and why...)

2525 Impulsive or premeditative? (and why...)

2526 Steamed or roasted vegetables? (and why...)

2527 Baby toes or puppy paws? (and why...)

2528 New car or fresh linen scent? (and why...)

2529 Citrus or tropical punch? (and why...)

2530 Tragedy or farce? (and why...)

2531 Arcade or action games? (and why...)

2532 Coffee cup or mug? (and why...)

2533 Salmon patties or crab cakes? (and why...)

2534 Popcorn machine or snow cone machine? (and why...)

2535 Ryan Seacrest or Carson Daly? (and why...)

2536 Mother's Day or Father's Day? (and why...)

2537 Looney Tunes or The Smurfs? (and why...)

2538 *Thunder Cats* or *Super Friends*? (and why...)

2539 Water polo or canoe polo? (and why...)

2540 Bee sting or spider bite? (and why...)

2541 2 liters or six pack? (and why...)

2542 Climb a tree or build a fort? (and why...)

2543 Break the ice or take a raincheck? (and why...)

2544 Skip rocks or paint rocks? (and why...)

2545 Tea bags or loose tea? (and why...)

2546 Bend the rules or follow the rules? (and why...)

2547 Rapunzel or Rumpelstiltskin? (and why...)

2548 Coffee table or side table? (and why...)

2549 Red Hot Chili Peppers or Green Day? (and why...)

2550 Strategy or hidden object games? (and why...)

2551 Pasteurized or non-pasteurized? (and why...)

2552 Bass or treble? (and why...)

2553 Miley Cyrus or Hannah Montana? (and why...)

2554 *Jimmy Kimmel Live!* or *The Late Late Show with James Corden?* (and why...)

2555 Tarts or turnovers? (and why...)

2556 Nectarines or peaches? (and why...)

2557 Toile or chevron pattern? (and why...)

2558 VIP or private room? (and why...)

2559 One player or two player games? (and why...)

2560 Skeletons in the closet or air your dirty laundry? (and why...)

2561 Standard or oversized? (and why...)

2562 Colloquialisms or idioms? (and why...)

2563 Grind or hustle? (and why...)

2564 Castaway or held captive? (and why...)

2565 Standards or morals? (and why...)

2566 Pun or adage? (and why...)

2567 Monastery or convent? (and why...)

2568 Roaches or ants? (and why...)

2569 Mosquitos or fleas? (and why...)

2570 Upright or grand piano? (and why...)

2571 Guardian angel or godparent? (and why...)

2572 Yogurt or chocolate dipped pretzels? (and why...)

2573 Fake or real Christmas tree? (and why...)

2574 Adirondack or beach chair? (and why...)

2575 Long distance relationship: yes or no? (and why...)

2576 Chapel or cathedral? (and why...)

2577 Tango or cha cha? (and why...)

2578 *Charlotte's Web* or *Babe*? (and why...)

2579 Cane sugar or sugar in the raw? (and why...)

2580 Meadow or valley? (and why...)

2581 Pineapple or mango salsa? (and why...)

2582 Symbolic or ritualistic? (and why...)

2583 Ocean or city view? (and why...)

2584 Pate or fromage? (and why...)

2585 Keegan-Michael Key or Jordan Peele? (and why...)

2586 Dalmatian or greyhound? (and why...)

2587 Intuition or conscience? (and why...)

2588 Thor or Captain America? (and why...)

2589 Veggie chips or pita chips? (and why...)

2590 Bic or Paper Mate pen? (and why...)

2591 Revlon or Almay? (and why...)

2592 *Two and a Half Men* or *Modern Family*? (and why...)

2593 Build your credit or save money? (and why...)

2594 Radish or turnip? (and why...)

2595 Face mask or face peel? (and why...)

2596 Mandala or Lotus tattoo? (and why...)

2597 Rubik's Cube or Triangle Peg Board Game? (and why...)

2598 Peyton or Eli Manning? (and why...)

2599 Sand art or blown glass? (and why...)

2600 The Treblemakers or The Barden Bellas? (and why...)

2601 Crown chakra or third-eye chakra? (and why...)

2602 Flip or Flop or Fixer Upper? (and why...)

2603 Whey or plant-based protein powder? (and why...)

2604 Pulp or no pulp orange juice? (and why...)

2605 Grow herb or vegetable garden? (and why...)

2606 White lies or broken promises? (and why...)

2607 Hotline Bling or Call Me Maybe? (and why...)

2608 Chainsmokers or Cold Play? (and why...)

2609 Vevo or Vimeo? (and why...)

2610 Wile E. Coyote or Roadrunner? (and why...)

2611 Time-lapse or long exposure? (and why...)

2612 *Robot Chicken* or *The Venture Brothers*? (and why...)

2613 Manicotti or tortellini? (and why...)

2614 Don't worry be happy or keep calm and carry on? (and why...)

2615 *High School Musical* or *Pitch Perfect*? (and why...)

2616 Rise and shine or sleep tight? (and why...)

2617 Autobots or Decepticons? (and why...)

2618 Styrofoam or paper plates? (and why...)

2619 Grilled or raw onions? (and why...)

2620 Bagel dog or pretzel dog? (and why...)

2621 Dolly Parton or Reba McIntire? (and why...)

2622 Bobble head doll or sock monkey? (and why...)

2623 Air Force One or Air Jordan Sneakers? (and why...)

2624 Free gas or free food? (and why...)

2625 Pre-school or high school teacher? (and why...)

2626 Solids or patterns? (and why...)

2627 Hello Fresh or Blue Apron? (and why...)

2628 Calzone or Stromboli? (and why...)

2629 Optimus Prime or Megatron? (and why...)

2630 Bikram or Yin yoga? (and why...)

2631 Hypnosis or self-hypnosis? (and why...)

2632 *Les Miserables* or *The Three Musketeers*? (and why...)

2633 With or without cheese? (and why...)

2634 National anthem: stand or kneel? (and why...)

2635 Nutter Butter or Fig Newtons? (and why...)

2636 Lime or lemon? (and why...)

2637 Cayenne or chipotle? (and why...)

2638 Uber Eats or GrubHub? (and why...)

2639 Free shipping or 20% discount? (and why...)

2640 Continental drift or plate-tectonics? (and why...)

2641 Megalodon or T-Rex? (and why...)

2642 Watch Super Bowl or watch the commercials only? (and why...)

2643 Dig deep or running on fumes? (and why...)

2644 Chewy or crispy cookies? (and why...)

2645 Live next door to cemetery or chemical plant? (and why...)

2646 DQ blizzard or McDonald's flurry? (and why...)

2647 Accidentally or unexpectedly? (and why...)

2648 Stability or excitement? (and why...)

2649 Smart or hybrid car? (and why...)

2650 Hummingbird or morning dove? (and why...)

2651 OPI or Essie nail polish? (and why...)

2652 Lightning or thunder? (and why...)

2653 Jabba Wockeez or Super Cr3w? (and why...)

2654 *Cirque du Soleil* or *Blue Man Group*? (and why...)

2655 *Pen & Teller* or *Siegfried and Roy*? (and why...)

2656 Hail or sleet? (and why...)

2657 Gummy worms or bears? (and why...)

2658 Lyrics or beat of a song? (and why...)

2659 Fierce or fabulous? (and why...)

2660 Rap or flow? (and why...)

2661 Chopped or tossed salad? (and why...)

2662 Questions or answers? (and why...)

2663 Short or tall? (and why...)

2664 Mount Everest or K2? (and why...)

2665 "You complete me" or "I wish I knew how to quit you"? (and why...)

2666 "Wax on, wax off" or "Go ahead, make my day"? (and why...)

2667 "You can't handle the truth" or "You had me at hello"? (and why...)

2668 Turtlenecks: yes or no? (and why...)

2669 Hopscotch or double-dutch? (and why...)

2670 Pawn shop or resale shop? (and why...)

2671 Back or neck massager? (and why...)

2672 Identity or car theft? (and why...)

2673 Jousting or fencing? (and why...)

2674 Textured or smooth? (and why...)

2675 Drugstore or corner store? (and why...)

2676 Sashimi or poke? (and why...)

2677 Drink with a straw or without a straw? (and why...)

2678 Thrive or buckle under pressure? (and why...)

2679 Sweet-n-low or Splenda? (and why...)

2680 Milk a cow or sheer a sheep? (and why...)

2681 Termites or bed bugs? (and why...)

2682 Fantasy Sports League: win or lose? (and why...)

2683 Candle making or soap making? (and why...)

2684 Bodybuilding or parkour? (and why...)

2685 Apple iPhone or Samsung Galaxy? (and why...)

2686 Larp-ing or urban exploration? (and why...)

2687 Song or standard ringtone? (and why...)

2688 Fossil hunting or metal detecting? (and why...)

2689 Mountain or dirt bike? (and why...)

2690 Rodent or insect infestation? (and why...)

2691 Luke Skywalker or Anakin Skywalker? (and why...)

2692 Darth Vader or Darth Maul? (and why...)

2693 Smart watch or stylish watch? (and why...)

2694 Rock or Maine lobster? (and why...)

2695 Owls or bats? (and why...)

2696 Tom Jones or Wayne Newton? (and why...)

2697 Dance or rap battle? (and why...)

2698 White or pink sand beaches? (and why...)

2699 Stand or hand mixer? (and why...)

2700 *Good Morning America* or *Today Show*? (and why...)

2701 Step your game up or leave no stone unturned? (and why...)

2702 Go down in flames or crunch time? (and why...)

2703 Letgo or OfferUp? (and why...)

2704 Kellogg or Post? (and why...)

2705 Snail mail or FedEx? (and why...)

2706 Hula hoop or twirl baton? (and why...)

2707 *That '70s Show* or *The Office*? (and why...)

2708 *Parks and Recreation* or *Arrested Development*? (and why...)

2709 *Motor Trend* or *Popular Mechanics*? (and why...)

2710 *Better Homes and Gardens* or *Real Simple*? (and why...)

2711 Match.com or eHarmony? (and why...)

2712 Fiverr or HubPages? (and why...)

2713 Bath and Body Works candle or Yankee Candle? (and why...)

2714 "Another One Bites the Dust" or "We are the Champions"? (and why...)

2715 Pocket watch or wristwatch? (and why...)

2716 Flushed or blushing? (and why...)

2717 Beach Boys or Bee Gees? (and why...)

2718 "Sweet Caroline" or "It's Not Unusual"? (and why...)

2719 Stomach ache or headache? (and why...)

2720 Drive: windows down or AC on? (and why...)

2721 Domestic or foreign car? (and why...)

2722 Dirty laundry or dirty dishes? (and why...)

2723 Club sandwich: toasted or not toasted? (and why...)

2724 Pop quiz or final exam? (and why...)

2725 Liberty or virtue? (and why...)

2726 Skunk spray or porcupine quills? (and why...)

2727 Dozen long stem roses or gourmet box of chocolates? (and why...)

2728 20th or 21st century? (and why...)

2729 Coming of age or who done it story? (and why...)

2730 Identity crisis or anxiety attack? (and why...)

2731 Pastor or priest? (and why...)

2732 Family or workplace drama? (and why...)

2733 Lunges or crunches? (and why...)

2734 Misdeeds or malevolence? (and why...)

2735 Duracell or Energizer battery? (and why...)

2736 Séance or Ouija Board? (and why...)

2737 Mortal Kombat or Zelda arcade? (and why...)

2738 Kendall or Kylie Jenner? (and why...)

2739 Pee Wee Herman or Carrot Top? (and why...)

2740 Burpees or squats? (and why...)

2741 Death penalty: for or against? (and why...)

2742 May the force be with you or live long and prosper? (and why...)

2743 Guitar Hero or Dance Dance Revolution? (and why...)

2744 Pros or Cons? (and why...)

2745 Prego or Ragu? (and why...)

2746 Steve Urkel or Screech Powers? (and why...)

2747 Celebrity or nature screensaver? (and why...)

2748 Oysters or scallops? (and why...)

2749 Pinball or Hoop Fever machine? (and why...)

2750 Family time or me time? (and why...)

2751 Degree or Secret deodorant? (and why...)

2752 Dry or fresh herbs? (and why...)

2753 Job interview or parent/teacher conference? (and why...)

2754 Lazy eye or unibrow? (and why...)

2755 Police station or courtroom? (and why...)

2756 Stroll in the park or window shop? (and why...)

2757 Functional or dysfunctional? (and why...)

2758 Hug or embrace? (and why...)

2759 Spiked or wavy hair? (and why...)

2760 *Incredibles* or *Despicable Me*? (and why...)

2761 Kiss on the forehead or cheek? (and why...)

2762 *The Blind Side* or *Erin Brockovich*? (and why...)

2763 Lost in translation or lost in emotion? (and why...)

2764 Dance: twirl or dip? (and why...)

2765 Squeak or squeal? (and why...)

2766 *America's Funniest Home Videos* or *Ridiculousness?* (and why...)

2767 Bouquet or centerpiece? (and why...)

2768 Bread and butter or toast and jam? (and why...)

2769 *Madagascar* or *Ice Age*? (and why...)

2770 Scavenger hunt or musical chairs? (and why...)

2771 *Hotel Transylvania* or *Kung Fu Panda*? (and why...)

2772 Breakfast cereal: crunchy or soggy? (and why...)

2773 *Full House* or *Fuller House*? (and why...)

2774 Eat to live or live to eat? (and why...)

2775 Queen Elizabeth I or II? (and why...)

2776 Scandal or Empire? (and why...)

2777 Facial hair or no facial hair? (and why...)

2778 Two truths and a lie or name that tune? (and why...)

2779 Battleship or Risk? (and why...)

2780 Cookie bars or cookie sandwiches? (and why...)

2781 Boost or Metro PCS? (and why...)

2782 The hard way or shortcuts? (and why...)

2783 Read the book or Cliffsnotes? (and why...)

2784 Coffee or tea pot? (and why...)

2785 Biscotti or Linzer Cookies? (and why...)

2786 About.com or Ancestry.com? (and why...)

2787 Busy as a bee or at a snail's pace? (and why...)

2788 Polo or bowling shirt? (and why...)

2789 Dog eat dog or the world is your oyster? (and why...)

2790 Drew Carey or Bob Barker? (and why...)

2791 *Dirty Jobs* or *Mythbusters*? (and why...)

2792 Loverboy the band or movie? (and why...)

2793 Sea turtle or sea lion? (and why...)

2794 Millennium Falcon or Death Star? (and why...)

2795 Bellini or mimosa? (and why...)

2796 *This is Us* or *Gilmore Girls*? (and why...)

2797 Ball pit or trampoline? (and why...)

2798 Cabaret or belly dancing? (and why...)

2799 TSA or flight attendant? (and why...)

2800 Bahn mi or po'boy? (and why...)

2801 Mick Jagger or Paul McCartney? (and why...)

2802 Pot holes or speed bumps? (and why...)

2803 Apples: peel or skin on? (and why...)

2804 Documentary or docudrama? (and why...)

2805 Precognition or psychokinesis? (and why...)

2806 Axe or BOD body spray? (and why...)

2807 J. Crew or Banana Republic? (and why...)

2808 Sephora or Ulta Beauty? (and why...)

2809 Kroger's or Publix? (and why...)

2810 Gamestop or Gamefly? (and why...)

2811 Hot Topic or EXPRESS? (and why...)

2812 La Croix or ICE seltzer? (and why...)

2813 Single and ready to mingle or off the market? (and why...)

2814 Hot or iced tea? (and why...)

2815 *Forbes* or *The Wallstreet Journal*? (and why...)

2816 Memorial or Labor Day? (and why...)

2817 Fuji or Olympus? (and why...)

2818 Airbnb or VRBO? (and why...)

2819 Vampire Louie or Lestat? (and why...)

2820 Telepathy or shape shifting? (and why...)

2821 Just Do It or Taste the Rainbow? (and why...)

2822 David Bromstad or Nate Berkus? (and why...)

2823 *Martha Stewart Living* or *Goop* by Gwyneth Paltrow? (and why...)

2824 Siblings or only child? (and why...)

2825 IKEA or HomeGoods? (and why...)

2826 Elf on the Shelf or Advent calendar? (and why...)

2827 Hands on or delegate? (and why...)

2828 Dave Ramsey or Suze Orman? (and why...)

2829 Hammock or sleeping bag? (and why...)

2830 Harley Quinn or Poison Ivy? (and why...)

2831 Stationery or letterhead? (and why...)

2832 Tribeca or Hell's Kitchen? (and why...)

2833 Beef or chicken fajitas? (and why...)

2834 Ambitious or eager? (and why...)

2835 T.J. Maxx or Ross? (and why...)

2836 Jergens or St. Ives lotion? (and why...)

2837 Botox or facelift? (and why...)

2838 Agent Smith or Neo? (and why...)

2839 Gas or real wood burning fireplace? (and why...)

2840 Personalized stamper or personalized return labels? (and why...)

2841 Camping or backpacking? (and why...)

2842 Music or magazine subscription? (and why...)

2843 *Basic Instinct* or *Fatal Attraction*? (and why...)

2844 RTIC or Yeti? (and why...)

2845 Shazam or Sound Hound? (and why...)

2846 Grumpy or moody? (and why...)

2847 Easy or hard password? (and why...)

2848 Hola or Namaste? (and why...)

2849 Dance like nobody is watching or shake your booty? (and why...)

2850 Me, myself and I: G-Eazy or De La Soul version? (and why...)

2851 Ordinary or extraordinary? (and why...)

2852 Old school or new school? (and why...)

2853 Panda Express or Golden Corral? (and why...)

2854 Career or start a family or both? (and why...)

2855 TLC or Freeform network? (and why...)

2856 All bite or bark? (and why...)

2857 Overnight or weekender? (and why...)

2858 Duluth Trading Company or Red Wing? (and why...)

2859 Spirit animal or horoscope sign? (and why...)

2860 Peas or lima beans? (and why...)

2861 Woodstock or Tweety bird? (and why...)

2862 Tag or hide-and-seek? (and why...)

2863 Stove top or microwaveable? (and why...)

2864 The Joker or The Riddler? (and why...)

2865 GSN or TLC? (and why...)

2866 Over or undercooked? (and why...)

2867 Jarritos or Jumex? (and why...)

2868 Comedy or dance club? (and why...)

2869 Watch live TV or use DVR? (and why...)

2870 No brainer or brain fart? (and why...)

2871 *The Voice* judge: Adam Levine or Blake Shelton? (and why...)

2872 Mama June or Kate Gosselin? (and why...)

2873 *Big Bang Theory* or *Young Sheldon*? (and why...)

2874 *MTV Cribs* or *HGTV House Hunters*? (and why...)

2875 Newsletters: spam or informative? (and why...)

2876 Bank robbery or grand theft auto? (and why...)

2877 Wasabi: yay or nay? (and why...)

2878 Donate a kidney or bone marrow? (and why...)

2879 *Marriage Boot Camp* or *Bridezillas*? (and why...)

2880 Wedding vows: write your own or read a poem? (and why...)

2881 Liam Neeson or James Earl Jones voice? (and why...)

2882 Plastics from *Mean Girls* or Popular Girls from *Never Been Kissed*? (and why...)

2883 iPhone regular or plus? (and why...)

2884 Flo with Progressive or The Geico Gecko? (and why...)

2885 Smoothie King or Jamba Juice? (and why...)

2886 Hershey's with almonds or special dark? (and why...)

2887 All good things come to an end: true or false? (and why...)

2888 Metallica: turn it up or turn it off? (and why...)

2889 7-Eleven or Valero corner stores? (and why...)

2890 *A-Team* TV series or movie? (and why...)

2891 AC/DC or Def Leppard? (and why...)

2892 Crack your knuckles or your back? (and why...)

2893 Rookie or expert? (and why...)

2894 George Strait: king of country or who's that? (and why...)

2895 Charlie the Tuna or Aflac duck? (and why...)

2896 LMFAO or MGMT (band)? (and why...)

2897 Guilt trip or guilty conscience? (and why...)

2898 Snickers with almonds: better or worse than original? (and why...)

2899 Does history repeat itself: yes or no? (and why...)

2900 Lindsay Lohan or Amanda Bynes? (and why...)

2901 Edible Arrangements or Cookie bouquets? (and why...)

2902 Get This Party Started or Party Rock Anthem? (and why...)

2903 The movie or the book? (and why...)

2904 Green Giant or Mr. Clean? (and why...)

2905 Innocent until proven guilty or guilty until proven innocent? (and why...)

2906 Derek Jeter or A-Rod? (and why...)

2907 Laundry or dishes? (and why...)

2908 Self-love or love thy neighbor? (and why...)

2909 Angel or pufferfish? (and why...)

2910 Tin or shingle roof? (and why...)

2911 Drag or street racing? (and why...)

2912 Art or music festival? (and why...)

2913 FFA or 4-H? (and why...)

2914 Lucky number: 7 or 13? (and why...)

2915 Mark Cuban or Kevin O' Leary? (and why...)

2916 Hippocratic oath or Oath of Allegiance? (and why...)

2917 Ice Cube or Ice-T? (and why...)

2918 Shattered or torn? (and why...)

2919 Cremation or burial? (and why...)

2920 Drunk text parent or ex? (and why...)

2921 Zac Efron or Zach Galifianakis? (and why...)

2922 Selena Gomez or Ariana Grande? (and why...)

2923 Runkeeper or Nike Run Club? (and why...)

2924 Strawberry or raspberry lemonade? (and why...)

2925 Carbs: in moderation or load me up? (and why...)

2926 Açaí or goji berries? (and why...)

2927 Ancestry or volunteer trip? (and why...)

2928 Meal prep: waste of time or game changer? (and why...)

2929 Rise and shine or good morning sunshine? (and why...)

2930 Peace out or bye bye? (and why...)

2931 What's up or Sup? (and why...)

2932 Jennifer Lawrence or Jennifer Hudson? (and why...)

2933 Portrait or landscape? (and why...)

2934 DC Shoes or Puma? (and why...)

2935 Casseroles: yummy or yucky? (and why...)

2936 Brain teasers or riddles? (and why...)

2937 *Match Game* or *Whose Line is it Anyway*? (and why...)

2938 The CW or CBS? (and why...)

2939 White or black nail polish? (and why...)

2940 Ice cold or room temperature water? (and why...)

2941 Shark or Dyson? (and why...)

2942 Aisha Tyler or Tyler Perry? (and why...)

2943 Chin cleft: hot or not? (and why...)

2944 Henry Cavill or Christopher Reeves as Superman? (and why...)

2945 Gambler or risk taker? (and why...)

2946 Capers or olives? (and why...)

2947 Aunt or grandma? (and why...)

2948 Uncle or grandpa? (and why...)

2949 Richard Branson or Warren Buffet? (and why...)

2950 Fake ID or fake accent? (and why...)

2951 Honey Bunches of Oats or Honeycomb cereal? (and why...)

2952 Local or raw honey? (and why...)

2953 Bone broth or kombucha? (and why...)

2954 Evol or Lean Cuisine? (and why...)

2955 KIND or Luna bars? (and why...)

2956 Field trip or digital detox trip? (and why...)

2957 Wood or aluminum bat? (and why...)

2958 Vitamin Water or Sobe Lifewater? (and why...)

2959 Yoplait or Chobani? (and why...)

2960 Annie's or Amy's natural foods? (and why...)

2961 Shrimp cocktail or cocktail wieners? (and why...)

2962 Inherit money or a wine vineyard? (and why...)

2963 Crybaby or busybod? (and why...)

2964 Scotch Brite or Scrub Daddy? (and why...)

2965 Boneless or bone-in wings? (and why...)

2966 Tipsy Elves or Grace and Lace? (and why...)

2967 Banana split or brownie sundae? (and why...)

2968 Canadian or turkey bacon? (and why...)

2969 Stuffed crust pizza: yes please or no way? (and why...)

2970 Good or bad sportsmanship? (and why...)

2971 Stunt driver or stunt actor? (and why...)

2972 Michelle Williams: actress or singer? (and why...)

2973 *Gladiator* or *Braveheart*? (and why...)

2974 *America's Got Talent*: hit or miss? (and why...)

2975 Wings of an eagle or heron? (and why...)

2976 Bongos or xylophone? (and why...)

2977 Eddie Van Halen or Slash? (and why...)

2978 Walk on eggshells or cool as a cucumber? (and why...)

2979 "Ain't That a Kick in the Head" or "Come Fly With Me"? (and why...)

2980 Boudin or chorizo? (and why...)

2981 Lemon pie or lemon bars? (and why...)

2982 Paradise lost or found? (and why...)

2983 Sleeves or sleeveless? (and why...)

2984 Ripped jeans: hot or not? (and why...)

2985 Poshmark or Modcloth? (and why...)

2986 Bedazzle: love it or hate it? (and why...)

2987 Deep fryer or air fryer? (and why...)

2988 Plantar fasciitis or a broken toe? (and why...)

2989 Tendonitis or carpal tunnel? (and why...)

2990 Blank Space or You Belong with Me? (and why...)

2991 Painting or photograph? (and why...)

2992 New Kids on the Block or Boys II Men? (and why...)

2993 Burt's Bees or Toms? (and why...)

2994 Danica Patrick or Ronda Rousey? (and why...)

2995 Kung Pao or General Tso's? (and why...)

2996 Florida or California? (and why...)

2997 Comic Con or Met Gala? (and why...)

2998 Baseball cap: backwards, forwards or sideways? (and why...)

2999 Kid Rock or Dwayne the Rock Johnson? (and why...)

3000 Befriend Mom or boss on Facebook? (and why...)

Looking for more?

Similar titles available by Piccadilly:

300 Writing Prompts

300 MORE Writing Prompts

500 Writing Prompts

3000 Questions About Me

3000 Would You Rather Questions

Choose Your Own Journal

Complete the Story

Your Father's Story

Your Mother's Story

The Story of My Life

Write the Story

300 Drawing Prompts

500 Drawing Prompts

Calligraphy Made Easy

Comic Sketchbook

Sketching Made Easy

100 Life Challenges

Awesome Social Media Quizzes

Find the Cat

Find 2 Cats

Time Capsule Letters

WWW.PICCADILLYINC.COM